IMAGES
of America

CHICAGO'S
POLISH DOWNTOWN

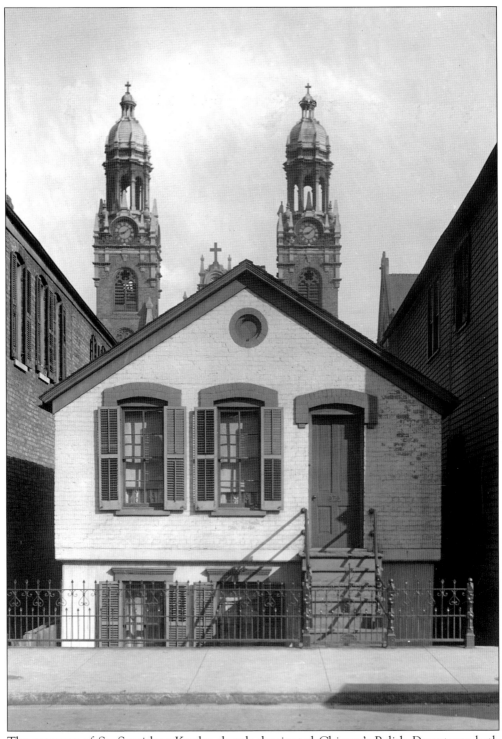

The presence of St. Stanislaus Kostka church dominated Chicago's Polish Downtown both physically and spiritually, with its twin towers rising high above the small cottages across Noble Street. (Courtesy of Chicago Park District Archives.)

IMAGES
of America

CHICAGO'S
POLISH DOWNTOWN

Victoria Granacki
in Association with
The Polish Museum of America

ARCADIA
PUBLISHING

Published by Arcadia Publishing
Charleston, South Carolina

Printed in the United States of America

Library of Congress Catalog Card Number: 2004103888

For all general information contact Arcadia Publishing at:
Telephone 843-853-2070
Fax 843-853-0044
E-Mail sales@arcadiapublishing.com
For customer service and orders:
Toll-Free 1-888-313-2665

Visit us on the Internet at www.arcadiapublishing.com

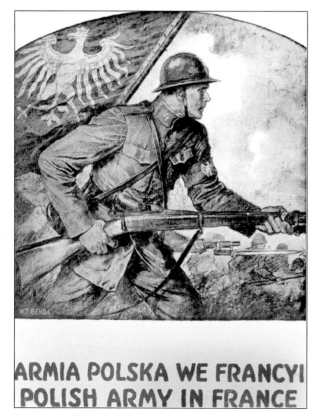

ARMIA POLSKA WE FRANCYI
POLISH ARMY IN FRANCE

About 25,000 American Poles, including 3,000 volunteers from Chicago, served in the Polish Army in France during World War I. Recruitment posters such as this one, designed by Polish-born artist W.T. Benda, appeared in churches and institutions all over Polonia. (Original art on display at The Polish Museum of America.)

CONTENTS

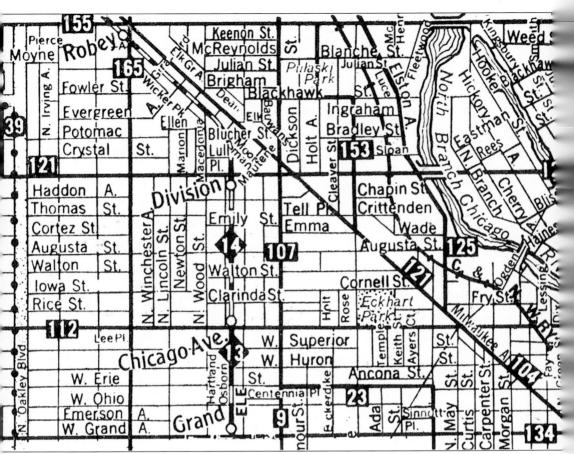

The heart of Old Polonia was clustered around the six-corner intersection of Division, Milwaukee, and Ashland avenues, and stretched for not much more than a half mile in any direction. This map from the Clason Map Company is undated but appears to be from the early 1900s. The numbers 13 and 14 in the black diamonds indicate the Logan Square and Humboldt Park West Side elevated train lines, which opened in 1895 and operated until 1952. Numbers in the black rectangles indicate streetcar lines that ran on Ashland Avenue (107), Division Street (121), Chicago Avenue (112), North Avenue (155), and Milwaukee Avenue (104).

INTRODUCTION

Chicago's "Polish Downtown" from the late 19th throughout the first half of the 20th century was the capital of American Polonia. Known to its Polish residents as "Stanislowowo-Trojcowo," after St. Stanislaus Kostka and Holy Trinity, two of the largest Catholic parishes in the world, it grew up on the northwest side of the city of Chicago, around Division, Ashland, and Milwaukee avenues. By 1890 it was the city's largest Polish settlement, with almost half of all Chicago Poles living here. The neighborhood contained a rich complex of parish and community institutions so complete that they could provide nearly all the services residents required—religious, educational, political, economic, and recreational—without Poles ever needing to leave the area. Though the physical size of the neighborhood was compact, its influence was far-reaching. Nearly all Polish undertakings of any consequence in the United States through the world wars either started or were directed from this tight-knit neighborhood in Chicago.

Polish peasants emigrated to America beginning in the 19th century in search of *za chlebem* (bread). Based on census and immigration records, between 1897 and 1913 an estimated two million ethnic Poles left a European continent that no longer had a Polish nation. Polish lands had been occupied by foreign powers since 1795. Poles were attracted to cities of industry and so Chicago, with its superb transportation links to the East Coast and its burgeoning role in trade and industry, became this country's most Polish city. But Poles brought with them and cherished within their hearts a fervent dream to recreate a free Polish nation in the fatherland. In the early years of immigration the battling factions of American Polonia were always at odds over the best ways to do this. Those battles were often waged in Polish Downtown. But at the dawn of World War I all Polonia joined together, from their offices and churches and societies in Polish Downtown, to launch the "War for Poland." These efforts led to a free Poland in 1918 and provided countless relief packages to war-torn lands.

Polish community building in Chicago began with the organization of Catholic parishes and the formation of mutual aid societies to provide death benefits to members. The city's first Polish parish, St. Stanislaus Kostka, was founded here in 1867 and has long been considered a "mother" church. Practically all older Polish parishes owe their origins to its first pastor, Rev. Vincent Barzynski. Its rival, Holy Trinity, was located just two short blocks away. The combined membership of these parishes numbered over 60,000 in the early 1900s. Each parish met not just religious needs, but served as a community center—the center of a Catholic Pole's whole life. They sponsored literary societies, dramatic productions, choirs and concerts, recreational activities, and sports teams. And if St. Stanislaus founded a society, Holy Trinity was quick to found its own.

The headquarters for almost every major Polish organization in America were located in Polish Downtown, including the country's two largest fraternal associations, the Polish Roman Catholic Union of America and the Polish National Alliance. When these two fraternals would not let women join, Polish women, who played a strong role in their families, parishes, and communities, founded the Polish Women's Alliance around the corner. Polish Downtown was also the center of the Polish press in America. By 1910, four Polish-language daily newspapers

were published here, as well as scores of literature, drama, dictionaries, textbooks, and religious books. The storefronts along Noble Street, and later up and down Milwaukee Avenue, were filled with Polish-owned stores, restaurants, banks, and businesses of all kinds.

As you look at the streets of Polish Downtown and the faces of its early immigrants, you will be transported back to the spirit that was Chicago's old Polonia. To Polonia today we say, "*Sto Lat*"—may you live for a hundred years more.

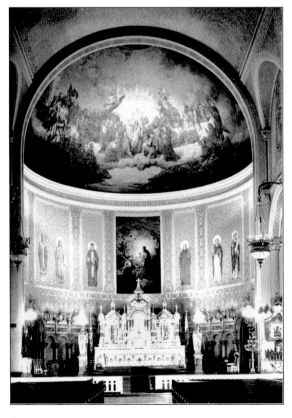

The interior of St. Stanislaus is 200 feet long and 80 feet wide, seating 1,500. The painting over the altar by Thaddeus Zukotynski depicts Our Lady placing the infant Jesus in the arms of St. Stanislaus Kostka. Zukotynski, who came to Chicago in 1888, was considered one of Europe's foremost painters of religious subjects. Other artistic treasures in the church include the stained glass windows by F. X. Zettler of the Royal Bavarian Institute in Munich and the chandeliers in the nave from the studios of Louis Tiffany.

One

POLISH CATHOLIC PARISHES

The heart of Chicago's Polonia, from its founding in the late 1860s, was its Catholic parishes. St. Stanislaus Kostka was the first Polish parish in Chicago and is considered the mother church of all Polonia. Organized in 1867 by the Society of St. Stanislaus, its first permanent pastor was Rev. Vincent Michael Barzynski, who served for over 25 years. St. Stanislaus eventually became one of the nation's largest Catholic parishes, with 35,000 worshippers.

The efforts of Rev. Barzynski and his Congregation of the Resurrection in the explosive expansion of Polonia's community/parish system were unmatched in Chicago by any other group. He is credited with either directly or indirectly organizing 23 Polish parishes, all with a host of associated societies, confraternities, and sodalities. Wherever a Polish colony settled, Barzynski would be there to build a church and supply a Resurrectionist priest or recommend a Polish-speaking diocesan priest to serve it. By the turn of the century, in Polish Downtown and nearby, in addition to St. Stanislaus and Holy Trinity, there were St. John Cantius, St. Mary of the Angels, St. Hedwig's, and St. Hyacinth's parishes. There were six parochial elementary schools, two high schools, one college, several orphanages, two newspapers, a Polish-run hospital, and the headquarters of the Polish Roman Catholic Union of America, all located in Polish Downtown and all benefitting from the indefatigable energy of one cleric.

Most Poles were Catholic but not all shared the Resurrectionist priority of Catholic first, Pole second. Within Chicago's Polonia was an intense fervor to reestablish a free Polish nation, which had been wiped off the map of Europe in 1795. This Polish nationalism found its religious home at Holy Trinity Church, just two blocks down Noble Street from St. Stanislaus. Holy Trinity struggled with St. Stanislaus for 20 years over Polish national politics and which priests would be in control. Organized in 1873 by the Resurrectionists, it closed five times until finally reopening in 1893 after a compromise was reached with the Chicago archdiocese appointing Holy Cross Fathers. Rev. Casimir Sztuczko, CSC, was named pastor and served for 35 years. Under him, Holy Trinity became a center of Polish National Alliance activities in Polonia and numbered 25,000 members. In fact the politics of America's Polonia, which became a struggle between the Unionists of the Polish Roman Catholic Union and the Alliancists of the Polish National Alliance, was split along the same deep divide that separated two of the largest Roman Catholic parishes in the world.

Into the 20th century, the Catholic parish remained the center of immigrant Poles' lives. In 1918, the combined parishes of St. Stanislaus, Holy Trinity, St. John Cantius, Holy Innocents, St. Hedwig's, and St. Mary of the Angels had over 100,000 parishioners within a one-mile radius. With their enormous investment in physical plants, these parishes kept the residential neighborhoods and commercial streets of Polish Downtown dense, stable, and Polish through the end of World War I. Though the grandchildren of the first immigrants have moved to other

city and suburban communities, the churches still stand as sentinels of Polish Catholicism in the heart of Chicago's Old Polonia. In some cases they serve new Polish immigrants, while in others they have found new congregations, but they continue to display the architectural and artistic excellence that is a testament to the faith and fervor of their immigrant Polish founders. (Photographs in this chapter are from the archives of The Polish Museum of America except as noted.)

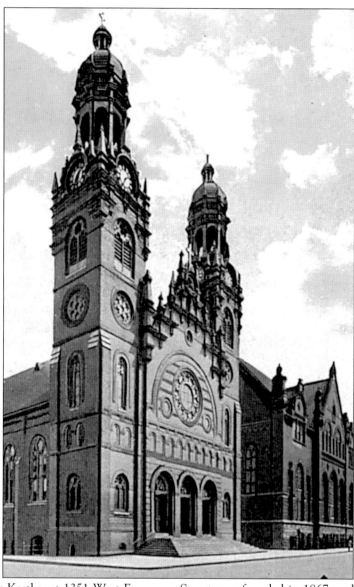

St. Stanislaus Kostka, at 1351 West Evergreen Street, was founded in 1867 as the first Polish parish in the Roman Catholic Archdiocese of Chicago. The current structure, designed by Patrick C. Keeley and built in 1876-1881, was modeled after a church in Krakow, Poland. It is in the Renaissance Revival style, a style favored by Poles as a reminder of the most glorious days of the Polish Commonwealth in the 16th and 17th centuries. The southern cupola was destroyed by lightning in 1964 and the northern cupola was rebuilt with a more simplified profile in 2002. (Collection of the author.)

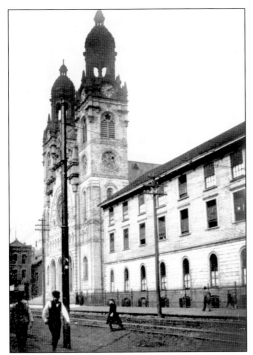

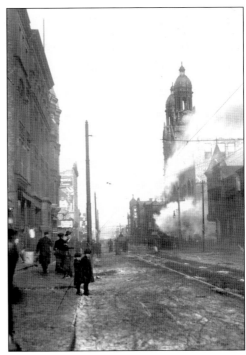

(*left*) The two-block physical plant contained a large hall for performances, a convent and rectory, a gymnasium, and both a grammar school and a two-year commercial high school for girls, staffed by the Sisters of Notre Dame. This photo shows the present church and the old hall in about 1901.

(*right*) In 1906, a fire burned to the ground a school, convent, and auditorium that were under construction. Under the pastorate of Rev. Francis Gordon, the cornerstone for a new school was laid on May 31, 1907. Five stories high with 54 classrooms and three meeting halls, it was the largest elementary school in the United States when it opened in 1908.

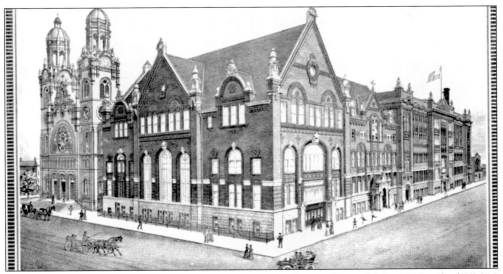

St. Stanislaus was once one of the largest Catholic parishes in the world. In 1908, it had 35,000 members. The parish sponsored numerous religious fraternities and sodalities; dramatic, literary and choral societies; and athletic teams.

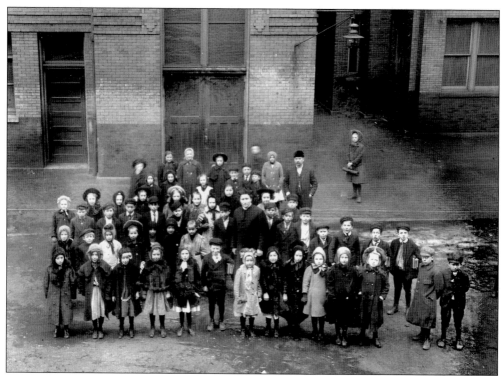

In 1910, there were 3,829 pupils in St. Stanislaus' grammar school. This photo shows schoolchildren in the early 1900s. St. Stanislaus elementary school is still open today.

A commercial high school for girls at St. Stanislaus opened in 1914 in the same building as the elementary school. A new structure for the high school was built in 1959 and the two were connected across what was Potomac Street by this sky bridge. The 1908 school building was demolished in 1978 after the elementary school moved into the 1959 structure.

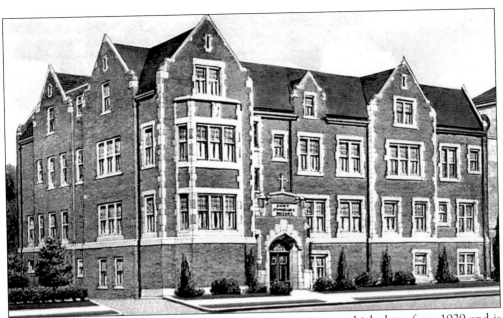

The first rectory was built in 1878. This is the present rectory, which dates from 1929 and is located behind the church on Evergreen Street. This structure is familiar today to anyone who approaches Chicago's Loop driving south on the Kennedy Expressway. Through the intense efforts of Chicago's Polonia in the late 1950s, the planned right of way was shifted between Division Street and North Avenue to avoid demolishing St. Stanislaus' parish buildings. (Collection of the author.)

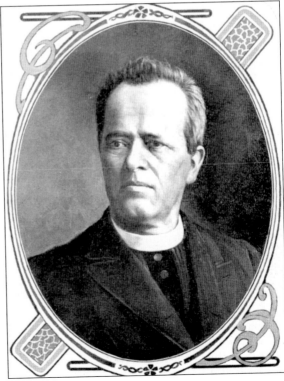

Rev. Vincent Michael Barzynski was one of the greatest organizers of Polish immigrants in Chicago and America. Born in Poland in 1838, he was a veteran of the 1863 uprising in Poland, providing the insurrectionists with military supplies. Joining the Congregation of the Resurrection, he came to the United States in 1866, first settling in Texas and then coming to St. Stanislaus in 1872. He served as its pastor from 1874 until his death in 1899. He founded or assisted in founding 23 Polish Catholic parishes—all the Polish parishes founded in Chicago and its suburbs during his lifetime, St. Stanislaus Kostka College, and nearly 40 societies.

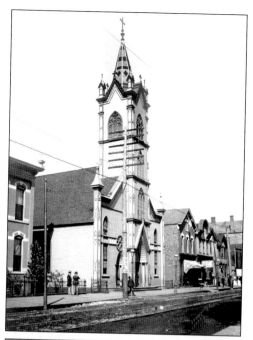

Holy Trinity parish was organized in 1873 but did not operate continuously until 1893. The 1873 church building was remodeled in 1895 by lengthening and extending it out to the street, remodeling the front façade, and constructing a more elaborate tower. This photo from 1901 shows the first church after that remodeling.

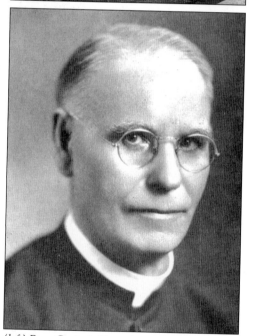

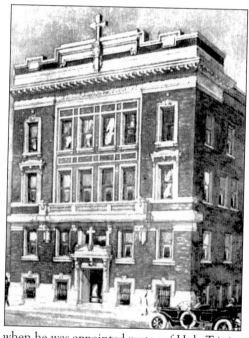

(*left*) Rev. Casimir Sztuczko was just 26 years old when he was appointed pastor of Holy Trinity parish in 1893 and he served there for over 55 years, until his death in 1949. Born in Poland, he was a graduate of Notre Dame University and a member of the Congregation of the Holy Cross. The Holy Cross Fathers were invited by Chicago's Archbishop Feehan to settle the 20-year struggle for control of the parish by the Resurrectionist priests of St. Stanislaus.
(*right*)The Holy Trinity rectory at 1118 North Noble Street was built in 1914 and was designed by the Rogers Company, with a pressed brick façade and classical stone ornamentation. Originally containing 31 rooms, today it serves as the parish offices.

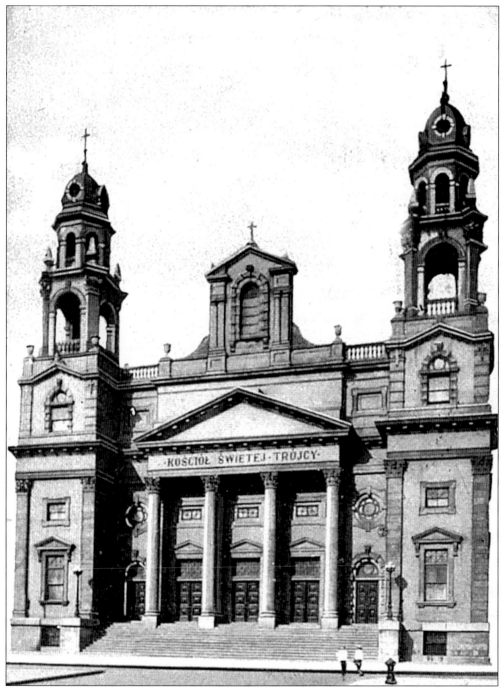

The present Holy Trinity church was built in 1905, with a cornerstone dated June 25, 1905. The original architect selected was Olzewski Von Herbulis of Washington D.C. His plans were too expensive, and when he couldn't get a building permit in Illinois, William Krieg of Chicago was chosen to modify his plans for construction. The church combines Renaissance styling with Baroque at the upper part of the façade. Four Corinthian columns support an entablature with *Kosciol Swiete; Trojcy* (Holy Trinity church) inscribed in Polish. (Collection of the author.)

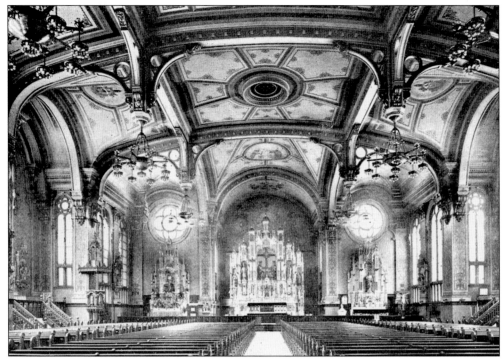

The interior plan of Holy Trinity Church is a hall-type church, 200 by 125 feet, with no nave or cross-aisles and no interior columns for support. The elaborate domed and coffered ceiling has pendants from which chandeliers are hung. This photo was taken before the ceilings were repainted by K. Markiewicz in 1926.

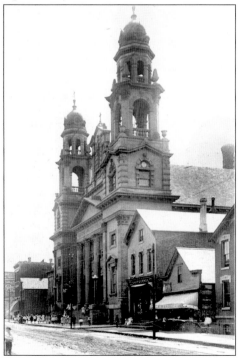

Holy Trinity was squeezed in beside smaller homes and businesses all along Noble Street. The parish operates today as Holy Trinity Polish Mission, serving Poles throughout Chicagoland under the Society of Christ Fathers, with all services conducted in Polish.

Although an elementary school had operated intermittently at Holy Trinity since 1877, the first school building was built for 700 pupils and opened in September 1894. Instruction was under the Sisters of the Holy Family of Nazareth, and the school population grew rapidly. In 1916 a larger elementary school was needed. This one was designed by the Rogers Company and built just behind the church on Cleaver Street. By 1923 the school had 3,000 pupils and was the largest parish school in the archdiocese. Although the elementary school no longer operates today, there is a Polish Saturday School run by the parish, with students being instructed in Polish language and culture. This building now houses the Mutual Aid Association of the New Polish Immigration in Chicago.

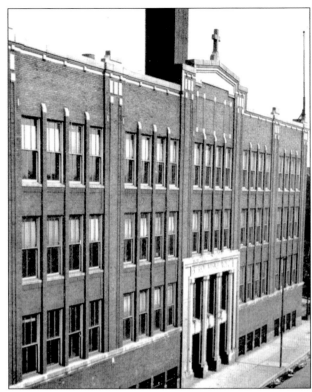

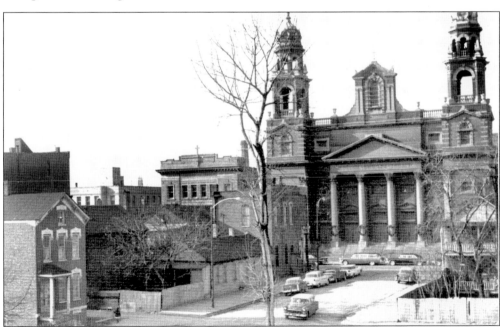

The federal Urban Renewal program came to Polish Downtown in the late 1950s. All of the businesses on Noble Street south of Division Street and many of the old homes and flats were demolished, as can be seen in this photo from 1958. Today this section of Noble is closed to traffic and there is a plaza opposite the front stairs of the church.

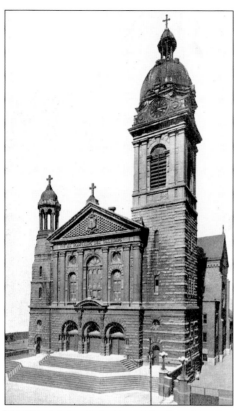

St. John Cantius was organized in 1893 by Rev. Vincent Barzynski, CR, for the overflow of parishioners from St. Stanislaus. Located at 825 North Carpenter, the cornerstone was laid on September 4, 1893, and the church was dedicated December 11, 1898. The pediment contains the Polish coat of arms and the Latin inscription *Ad Majorem Dei Gloriam* (For the greater glory of God). Its main tower rises 129 feet above the street and houses a clock and three bells. Recently the copper cupola on the tower was completely restored, faithfully following the design of the original.

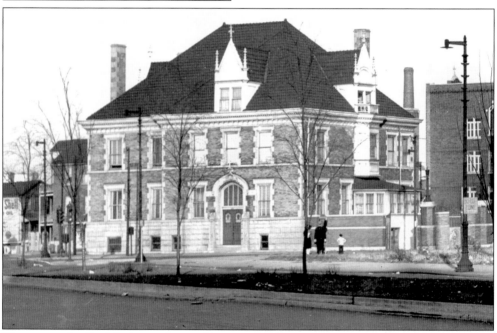

The rectory for St. John's was designed by noted ecclesiastical architect Henry J. Schlacks in a modified Gothic style, and was built in 1901–1902. A recent reconstruction to the original specifications of all the copperwork on the cornice and dormers was undertaken.

Designed by Adolphus Druiding in the Renaissance-Baroque style, St. John's is huge—230 feet long and 107 feet wide, with a seating capacity of 2,000. The interior, which features a Baroque altar of carved wood and gold ornament, was not completed until 1898. The side altar has a replica of the famous Black Madonna of Czestochowa, revered by Polish Catholics. The decline of St. John Cantius parish began in the 1920s after Ogden Avenue was extended through the area, breaking up the solid ethnic neighborhood. Construction of the Kennedy Expressway, which opened in 1960, also took its toll, clearing thousands of nearby homes and forcing many parishioners to leave. Since 1988, however, the parish has been revived, with a new pastor and the appeal of traditional Latin services and rich classical music, with orchestral and choir performances.

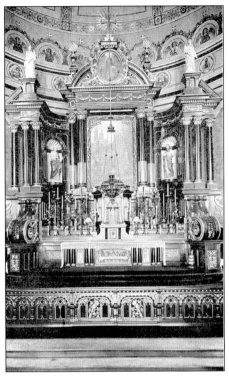

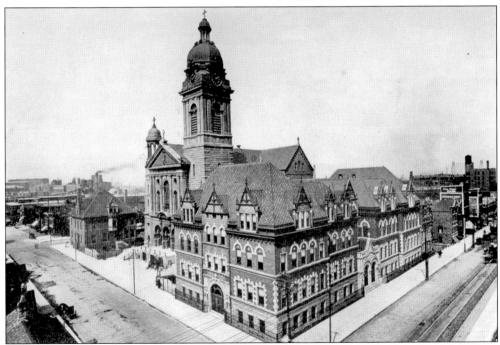

St. John's elementary school, which is prominently located on the corner of Chicago Avenue, was designed just two years later, also by Henry J. Schlacks. It opened in 1903, staffed by School Sisters of Notre Dame, and operated until 1967. This impressive structure is now occupied by the Chicago Academy of the Arts, a private high school for the visual and performing arts.

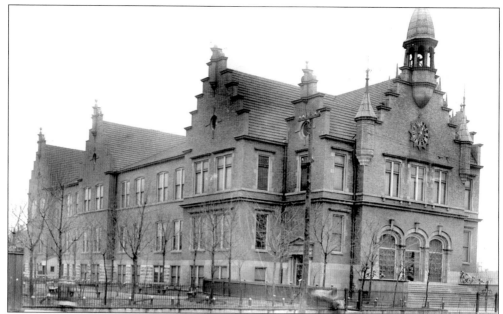

St. Mary of the Angels at 1825 North Wood was organized in 1897 by Rev. Francis Gordon, CR. The first combined church and school building was built in 1899 with a 1,500-seat auditorium and gymnasium and meeting halls in the basement, classrooms on the main floor, and the church on the second floor.

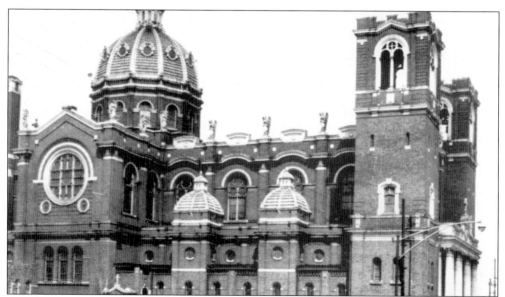

The new church building was dedicated on May 30, 1920. Designed by architects Worthmann & Steinbach, St. Mary's has been called the "finest example of Roman Renaissance architecture in the country." The large entry portico has eight Corinthian columns, and in the center of the entablature, the coat of arms of Pope Benedict XV. In 1988, St. Mary's was closed because of water leakage, falling plaster, and unsafe conditions. Parishioners raised over $1.2 million and Cardinal Bernadin consented to the restoration. Its doors reopened on October 11, 1992, under the pastorate of the Opus Dei priests.

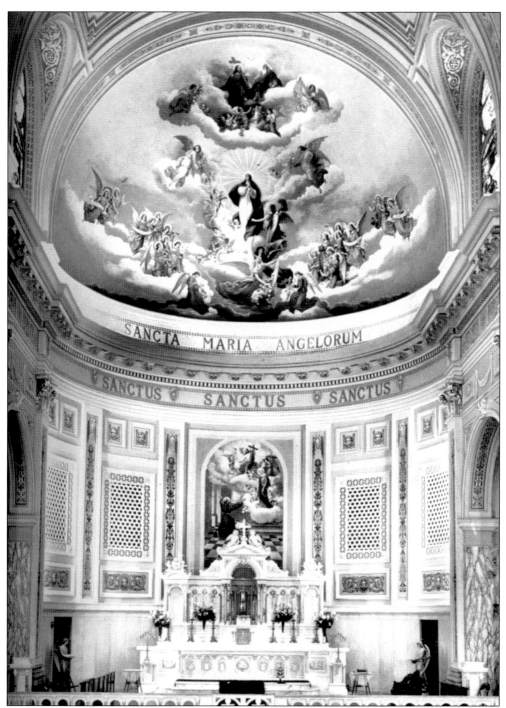

St. Mary's distinctive 135-foot dome was modeled after St. Peter's Basilica in Rome and has 68 stained glass windows of the 12 Apostles. The inscription reads "Glory to God in the Highest and Peace on Earth to Men." Right above the main altar of St. Mary's is a picture of St. Francis of Assissi's vision of Mary with Christ the King in heaven. Above that is a mural of the Assumption, painted by John A. Mallin in 1948.

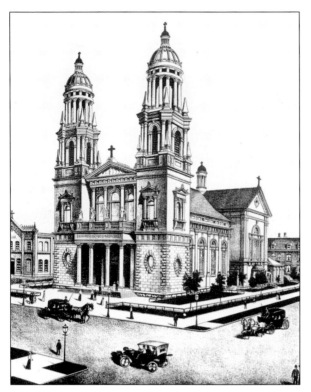

St. Hedwig's parish was organized in 1888 by St. Hedwig's Society and the Rev. Joseph Barzynski. The original plans called for two bell towers, as shown in this architectural rendering. They were not built at first, however, due to lack of funds. Then in 1925, the tops of the towers (but not the middle sections) were added.

The interior of St. Hedwig's features a series of murals under the arches and throughout the nave and transept. These were repainted by John A. Mallin of Chicago for the Parish Jubilee in 1938.

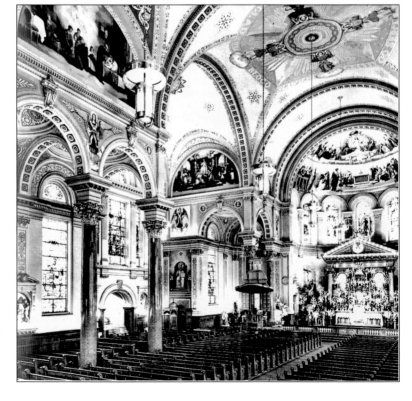

Located at 2226 North Hoyne Avenue, construction for the present St. Hedwig's church began in 1899, and it was dedicated in 1901. Designed by Adolphus Druiding and made of brick and Bedford stone in the Renaissance Revival style, it has a seating capacity of 1,500.

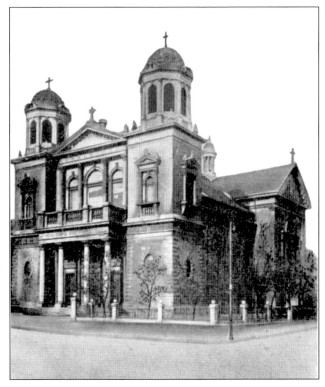

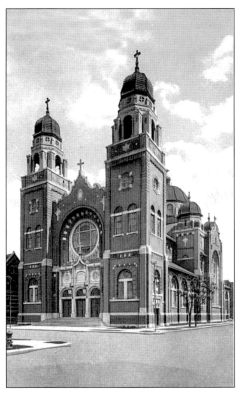

Holy Innocents Parish at 743 North Armour was one of the few Polish parishes in Chicago administered by diocesan, not Resurrectionist, priests. Organized in 1905, the first church and school were in buildings purchased from the German St. John Evangelical Lutheran church which had been built in 1867. The present church structure was built in 1910 and dedicated on October 20, 1912, under the pastorate of Rev. John Zwierzchowski. The Romanesque Revival design is by noted church architects Worthmann and Steinbach.

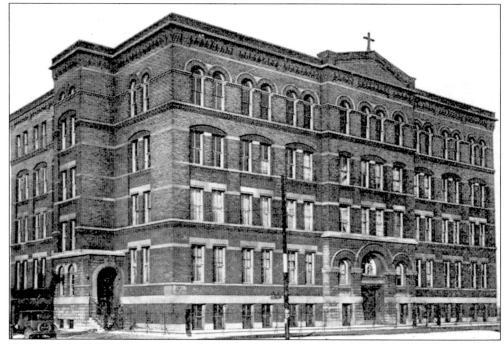

St. Stanislaus College first opened in a small frame building at the corner of Noble and Potomac streets within the St. Stanislaus Kostka parish complex. The first class had just 12 students and the first graduation ceremony was held on June 29, 1896, in the old St. Stanislaus Hall. By 1902 there were over 100 students and 11 faculty members. In 1899, the school moved to this building at the northeast corner of Division and Greenview that had been built in 1890 as an orphanage. St. Stanislaus was renamed Weber High School in 1930 in honor of the Most Rev. Archbishop Joseph Weber, CR, and remained at this location until Weber moved to 5252 West Palmer Street in 1950.

The early program of instruction at St. Stanislaus College was similar to the Central European "gymnasium" and included the Classics, English, Polish, German, and Latin, as well as a commercial course. After 1909 a six-year course was offered that conferred a Bachelor of Arts degree. After 1915 the school was gradually fashioned into an American-style high school. This is a class from 1910.

Two

POLISH SECONDARY SCHOOLS

By the end of the 19th century Polish immigrants were flooding into the neighborhoods and parishes of Polish Downtown. The Catholic families were large and poor, so that by the time their sons finished sixth grade, it was typical for them to leave school and start making a living. They might find work in the steel mills or other heavy industry, or they could be apprenticed in some kind of trade. There was no tradition and little interest in high school education when Rev. Vincent Barzynski proposed the first Polish college preparatory secondary school in Chicago in 1890. During the first few years, faculty had to beg and plead with parents to send their teenage boys to school even though tuition was only 25 cents a month. That covered six days of classes each week from September through July. In 1891, oral examinations were open to the public so students could demonstrate to their parents the great progress they had made in subjects such as English, Latin, math, history, and bookkeeping. Through the dedication of the early instructors, within a few years many parents became convinced of the value of education for their sons and enrollment began to increase. St. Stanislaus College was to become the start of higher education for many of Polonia's business, professional, and religious leaders.

Despite the eventual success of St. Stanislaus College, the pastor of Holy Trinity church was concerned that higher education was not available to enough young men. Only the more financially secure parents could afford the tuition for their sons to continue after grammar school graduation. Rev. Casimir Sztuczko's dream of a Catholic high school for boys that would impart the Polish language and culture that was being ignored by local public schools was realized with the founding of Holy Trinity High School. Opened in 1910 just across Division Street from St. Stanislaus, the school's operation was subsidized by the parish and thus available to more students.

The education of Polish girls began in a different way. With a flourishing parish elementary school system, it soon became apparent that more nuns were needed as teachers. Archbishop Feehan summoned to Chicago Mother Mary Frances Siedliska and her 11 religious women. They opened a novitiate on Division Street in 1885 to train Polish American recruits to their order. As part of their mission they also began offering evening classes for working girls in religion, literature, practical mathematics, and home arts. This was the beginning of Holy Family Academy, which opened as a full four-year high school in 1887. Then in 1914 St. Stanislaus parish organized a two-year commercial high school for girls within its large parish complex. The objective of this school was to prepare young girls for stenographic, secretarial, and clerical positions.

Thus within 25 years and located within just two blocks of one another, four Polish high schools were founded to serve either boys or girls. Only one of these, Holy Trinity, has operated continuously as a high school in this same location, and now educates boys and girls together. The Holy Family Academy buildings are occupied by Near North Montessori School and the site of the original St Stanislaus College is part of the Montessori campus. The St. Stanislaus Girls' High School building is now occupied by St. Stanislaus Kostka Elementary School. (Photographs in this chapter from the archives of The Polish Museum of America except those of Holy Family Academy are from the Congregation of the Sisters of the Holy Family of Nazareth.)

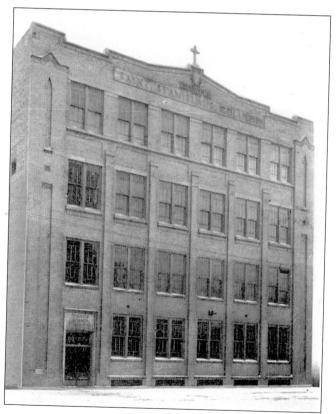

A building at 1521-1525 West Haddon Street was purchased in 1928 for additional facilities for St. Stanislaus College. It was remodeled, with a cafeteria on the ground floor, a gymnasium on the first floor, and classrooms and science laboratories on the top floor. This building is standing today but the windows are bricked in and it is used for storage. The name St. Stanislaus College can still be seen inscribed at the top.

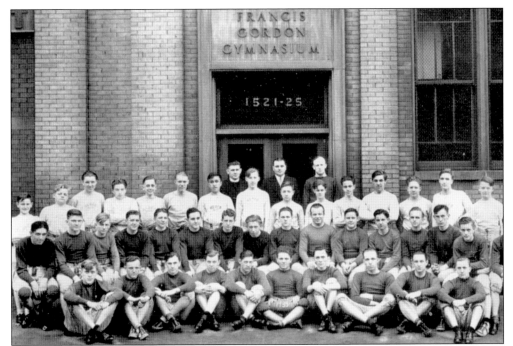

The 1935 Weber High School football team poses outside the Francis Gordon Gymnasium at 1521-1525 West Haddon Street, named in memory of Rev. Francis Gordon. Gordon Technical High School first began operation in the old Weber campus buildings here and on Division Street in 1952, after Weber had moved to a new campus in the Cragin neighborhood. Gordon is still open at 3633 North California but Weber closed in 1999.

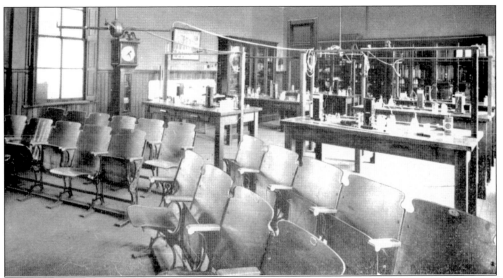

St. Stanislaus had a chapel, physics and chemistry laboratory, and a library of over 3,000 volumes. In 1911-1912, a business college was organized with a two-year commercial course offering day and evening classes. At the jubilee celebration in 1915, the school was lauded for being four schools in one: a Catholic school, a Polish school, a classical school, and a modern scientific school.

Holy Trinity High School was founded in 1910 by Rev. Casimir Sztuczko, CSC, pastor of Holy Trinity parish. On August 2, 1927, ground was broken for a new Holy Trinity High School at 1443 West Division Street. The dream of Rev. Sztuczko, the cleric in the center of this photo, was to establish a school that would serve Polish American youth by perpetuating Polish culture, language, and literature. The school was owned and supported by Holy Trinity parish.

The first Holy Trinity High School was located in the former Wladyslaus Dyniewicz printing plant at 1110 Noble Street. In 1912, the parish purchased this structure, the old Kosciuszko public school on the south side of Division Street near Cleaver. This building was later remodeled as a brothers' residence and has since been demolished.

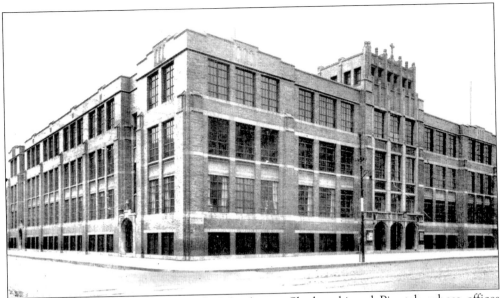

The architects for Holy Trinity High School were Slupkowski and Piontek, whose offices were just down Division Street at 1263 North Paulina. The 1928 building contained an auditorium, science laboratories, a library, gymnasium, cafeteria, classrooms, and a bowling alley. The curriculum included a general high school course, a college preparatory course, and a commercial course. Today it is owned by the Brothers of the Holy Cross and operates as a co-ed Catholic high school with a multiethnic student body.

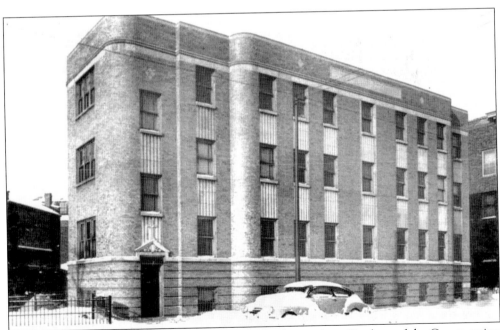

Holy Trinity High School was and still is staffed by the teaching Brothers of the Congregation of the Holy Cross. This structure on Noble Street was built in 1947 as the faculty house for the Brothers of Holy Trinity High School.

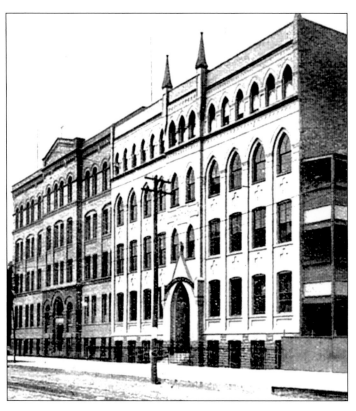

The building on the left, at the northwest corner of Division and Greenview, is St. Stanislaus College. Immediately to the right is Holy Family Academy, at 1444 West Division Street, built in 1892 by the Sisters of the Holy Family of Nazareth, with Mother Lauretta Lubowidzka as their guiding force. It was built with voluntary donations from people who understood the challenges and opportunities opening up for young women. Today Near North Montessori School occupies the Holy Family structures and the site of St. Stanislaus College is their playground. (Collection of the author.)

Holy Family Academy was founded in 1885 by Mother Mary Frances Siedliska and the Sisters of the Holy Family of Nazareth in a two-story brick building and adjoining one-story frame structure on this site. The first classes offered were in the evening as continuing education for working girls, but by 1887 a full-time academic program and boarding school for girls was made available. This was the first building constructed for the school in 1892.

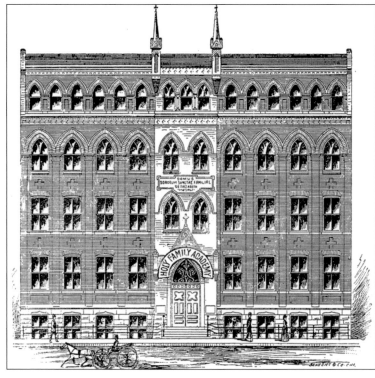

These students are on the front steps of the 1892 Holy Family school building in a photo from 1943.

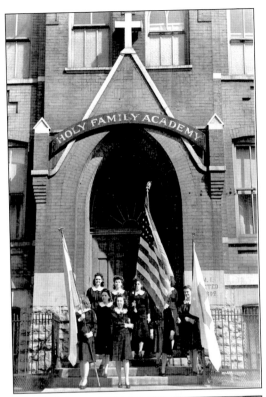

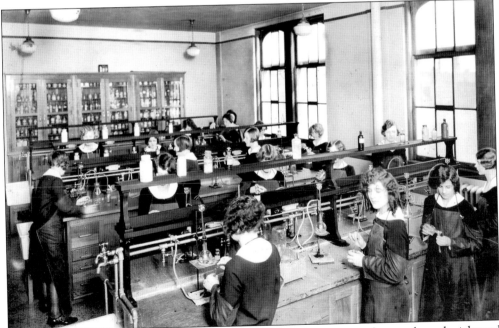

Holy Family Academy offered a full-time academic course covering grades one through eight and four years of high school. The general course of study for 1903-1904 is notable for instruction in four languages (English, Polish, French, and German) and a wide range of sciences. This is the chemistry laboratory in 1930.

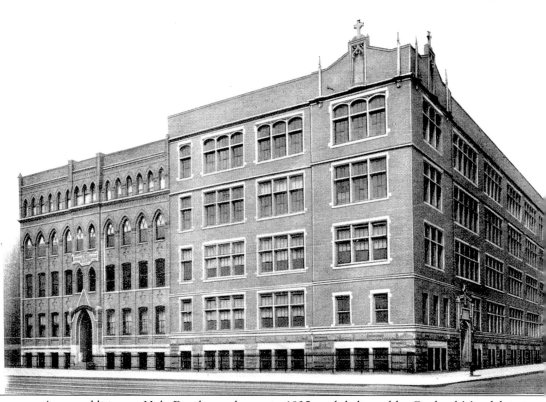

A new addition to Holy Family was begun in 1925, and dedicated by Cardinal Mundelein in 1927. This rendering from 1933 shows the 1892 building on the left and the 1927 building on the right.

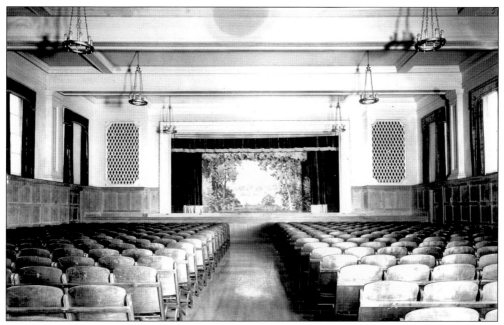

To continue operating in the older building while the new wing was under construction, the addition was built as a separate wing, with a chapel, auditorium, and swimming pool, together with additional classrooms. This is the auditorium in a 1930 photograph.

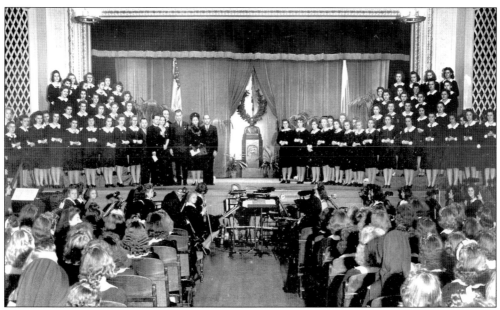

The music program at Holy Family included general music theory, private instruction in a variety of instruments, an orchestra, and choir. This is a music performance in the auditorium from 1930.

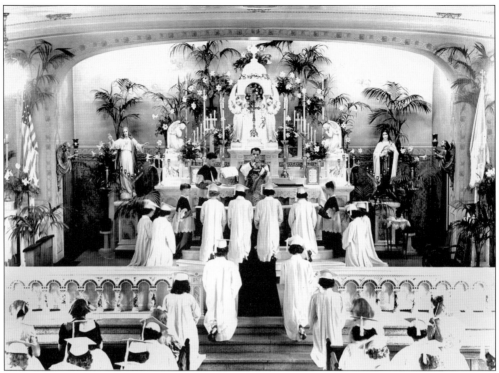

These Holy Family Academy graduates of 1943 are attending a baccalaureate mass in the chapel.

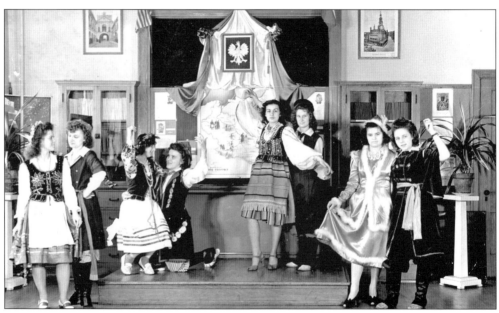

In the years through World War II, the student body of Holy Family Academy was primarily Polish. These girls from 1946 are dressed in native Polish costumes. In the 1950s and later, however, students of other races and ethnic backgrounds began attending. Holy Family remained open as a high school until the mid-1980s, when it was sold to Near North Montessori School for a private preschool and elementary school.

St. Stanislaus Kostka High School began with a two-year commercial course for girls in buildings at St. Stanislaus Kostka parish in 1914. The school was expanded in 1938-1939 to a standard four-year high school with the first graduation class in 1940. It operated in this structure until a new building was built in 1959. St. Stanislaus for girls closed in 1977 and this building was demolished the following year. The 1959 building is used today for St. Stanislaus Kostka elementary school.

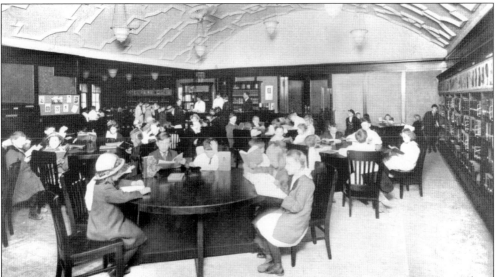

To further Polish language and culture among the children of Polish immigrants, Polish language classes were organized by the Polish National Alliance in 1908 in community centers at local Park District facilities. These students are studying in a branch of the public library on the second floor at Pulaski Park in about 1920. (Courtesy of Chicago Park District Archives.)

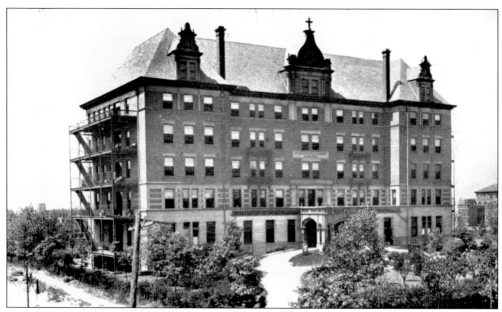

St. Mary of Nazareth Hospital is the oldest Polish hospital in Chicago, opened in 1894 by the Sisters of the Holy Family of Nazareth. Henry J. Schlacks was the architect for the large, 297-bed, five-story, red brick structure. The cornerstone was laid on June 16, 1901, and the doors opened less than a year later on March 12, 1902. This is the original hospital structure, but over the years, a number of wings were added. In 1924, a west wing for the School of Nursing and a new convent were built. In 1930 there were 114 sisters living and working at the hospital and by 1932, there were 152 sisters.

Situated in a residential neighborhood, St. Mary's structure was set back generously from Leavitt Street so that noise and dust wouldn't enter the building. There were verandas on the upper floors that gave a panoramic view of the city to the west, open porches on the north and south wings for convalescing patients, and a large garden in the rear, shown here.

Three

CHARITABLE INSTITUTIONS AND RELIGIOUS WOMEN

The education of children in parish schools and the care of orphans, the ill, and the aged within the Polish immigrant community were ministered largely by orders of religious women. The late 19th century was a time when the primary life choice for a woman was to be a wife and mother. For many women, becoming a nun offered an alternative life of prayer and service to others in a community controlled by women. Most of the social service welfare organizations that assisted Polish immigrants in the late 19th and early 20th centuries were founded and run by orders of religious women. Some of these orders were European, and when asked, they sent a small band of members to the United States as missionaries. Other orders were started here and attracted the daughters of immigrants. They were the Catholic response to social ills of the 1880s that were being addressed in the secular world by the women founding settlement houses. In time, large and complex institutions were administered by religious women.

The Sisters of the Holy Family of Nazareth was founded in Europe by a Polish noblewoman, Mother Mary Frances Siedliska, under the auspices of Pope Pius IX, in 1875. Ten years later, Archbishop Patrick Feehan called them to Chicago to a ministry among Polish immigrants. Their first motherhouse and novitiate was located on Division Street in Polish Downtown. When these quarters became too small, under the leadership of Mother Maria Lauretta Lubowidzka they built a new novitiate in 1908 in Des Plaines, where they are still located today. Their mission has always been to educate children and young women, to found and maintain asylums for the sick and needy, and to do other charitable works. Eventually 28 Chicago parish schools were staffed by this order, including Holy Trinity, St. Hedwig's, St. Josephat's, and St. Hyacinth's, as well as Holy Family Academy for girls. They founded and continue to staff St. Mary of Nazareth Hospital.

The first sisterhood founded in the city of Chicago was the Franciscan Sisters of Blessed Kunegunda (now known as the Congregation of the Franciscan Sisters of Chicago). The foundress was Josephine Dudzik, an immigrant Pole who came with her family to St. Stanislaus parish in 1881. She began her ministry by sheltering the poor, aged, and disabled in a small flat that she shared with her widowed mother on Haddon Street, and asked others to join her in a common life of prayer and service. As Sister Mary Theresa Dudzik, OSF, she founded St. Joseph's Home for the Aged and Crippled and St. Elizabeth's Day Nursery in Polish Downtown, and St. Hedwig's Orphanage, briefly in Chicago, but later in Niles, Illinois. The Franciscan Sisters of Chicago are very active today in building and operating residences for the elderly. Their motherhouse has been in Lemont since 1959.

There were several other orders of nuns with missions in Polish Downtown. Among these were the Felician Sisters, founded in Russian-occupied Poland in 1855, who staffed Holy Innocents parish school; the Sisters of the Resurrection, founded in Rome in 1891, who staffed St. Mary of the Angels parish school; and the School Sisters of Notre Dame, a non-Polish order of nuns, called by Rev. Barzynski to staff St. John Cantius and St. Stanislaus Kostka parish schools. All these orders continue to minister to Poles and to others in many areas throughout the city and suburbs. (Photographs in this chapter are courtesy of the Sisters of the Holy Family of Nazareth, the Franciscan Sisters of Chicago, and the Sisters of the Resurrection, unless otherwise noted.)

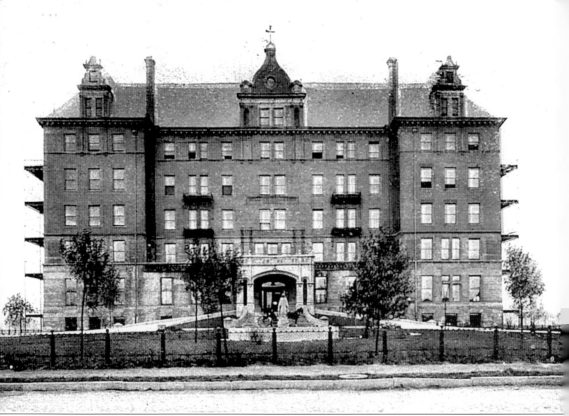

The first property occupied by St. Mary's was a three-story brick house at 1714-1722 West Division, bought in 1892. Doctors pledged to work the first year for no pay so that poor patients could be treated. In 1899, the sisters bought another frame building nearby. But with the growth in admissions, a full city block bounded by Haddon, Oakley, Leavitt, and Thomas streets was purchased and this structure was built. (Collection of the author.)

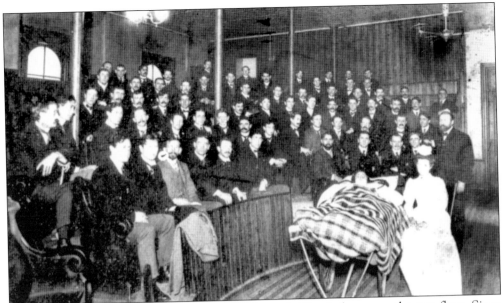

The principal surgery room at St. Mary of Nazareth Hospital was on the top floor. Since there was no electricity installed until 1914, there was one long window, 8 by 24 feet, and a large skylight for surgeons to work by daylight. St. Mary's was among Chicago's first hospitals to introduce physicians' clinics, or "Grand Rounds," in 1902 as an instructional technique involving direct observation of clinical procedures.

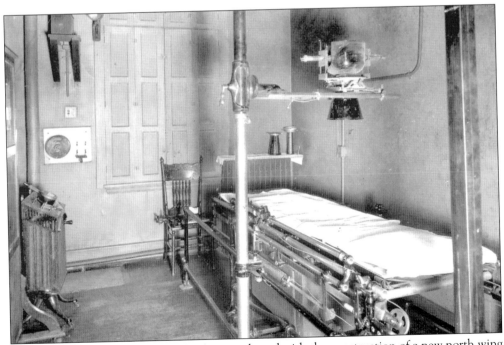

The surgical department for St. Mary's was enlarged with the construction of a new north wing in 1931. That enabled the hospital to replace this typical x-ray room from the 1920s with more modern equipment.

Mother Maria Lauretta Lubowidzka was entrusted by order foundress Mother Mary Frances Siedliska with the mission to start a hospital. Born in Poland in 1862, she came to this country in 1885 and became the first Mother Provincial of the Holy Family of Nazareth Sisters of the United States. She served in Chicago for 17 years. Her special concern was Polish schools, but she also opened a school for African-American children in Chicago in 1933. Mother Lubowidzka was called "the Saint of Division Street" as she walked through the streets of the neighborhood, able to speak to neighborhood residents in five languages.

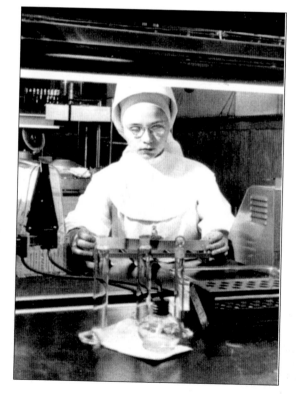

The top administrator of St. Mary of Nazareth Hospital was always a nun. Nuns were nurses, performed administrative functions, did all the manual work, were telephone operators, ran the elevators, worked in the laundry, the kitchen, the laboratories, and in every position except physician. The physicians, until at least the 1940s, were all men. During World War II, the number of student nurses and medical interns declined, so many sisters were trained to perform tasks previously done only by doctors. This is a nun in the laboratory in the 1940s.

Although when St. Mary's was founded the idea of sisters becoming nurses was unheard of, within just a few short years Dr. Albert Ochsner, chief of the medical staff, was urging that a professional nursing school be established. The school opened in 1900 and its first class graduated in 1903. The school was accredited by the State of Illinois in 1912 and in 1931 became affiliated with De Paul University so students could earn a bachelor of science in nursing degree. These graduates are outside the hospital chapel in 1943.

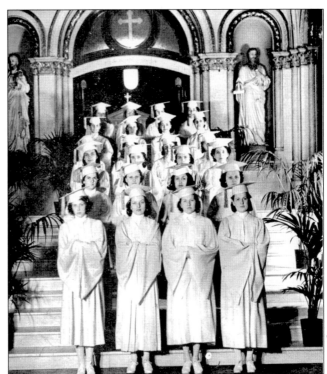

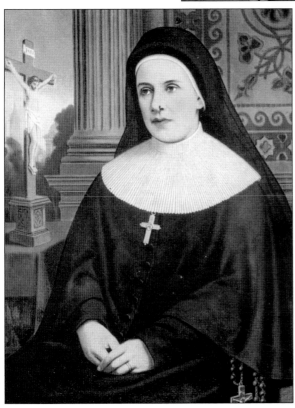

The Congregation of the Sisters of the Holy Family of Nazareth was founded in 1873 in Rome by Frances Siedliska who became known as Mother Mary of Jesus the Good Shepherd. She resisted the influence of her spiritual advisor that the order should be contemplative and live in a secluded monastery. Instead she chose an activist role for her sisters, serving the needy all over the world. So it was fitting that in the early 1960s, when St. Mary's Hospital became outdated and overcrowded and the area began to decline dramatically, the sisters decided to renew their commitment to the neighborhood. They acquired a site on Division Street, and broke ground for a new structure in 1972. At the topping-out ceremony in April 1974, Administrator Sister Stella Louise said, "We did not leave; we did not flee . . . we will stay [in this neighborhood] and fulfill the pledge our Sisters made many years before."

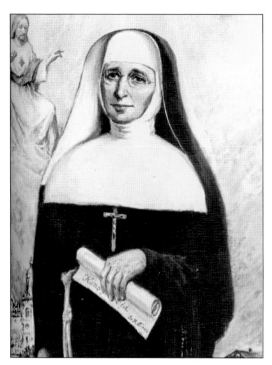

Josephine Dudzik was born in Poland in 1860 and came to St. Stanislaus parish with her parents in 1881. In 1893, she urged her friends to join her in a common life of prayer and service to the aged in the area. Her spiritual director, Rev. Vincent Barzynski, convinced the women to adopt the structure of a formal religious community. Sister Mary Theresa Dudzik and her three companions, Sister Anna Wisinski, Sister M. Angeline Topolinski, and Sister M. Agnes Dzik, did so on June 3, 1900. Dudzik became the first Mother General of the order. She died in 1918.

The newly founded Franciscan Sisters of Blessed Kunegunda began caring for the elderly in the Dudzik home at 11 Chapin (later 1341 West Haddon Street), with founder, Sister Mary Theresa Dudzik. Built in 1885, this house was demolished in 1965 as part of the Chicago Department of Urban Renewal's Project Noble-Division.

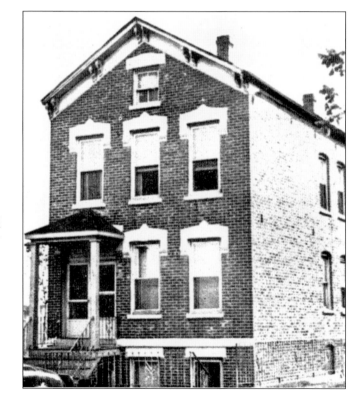

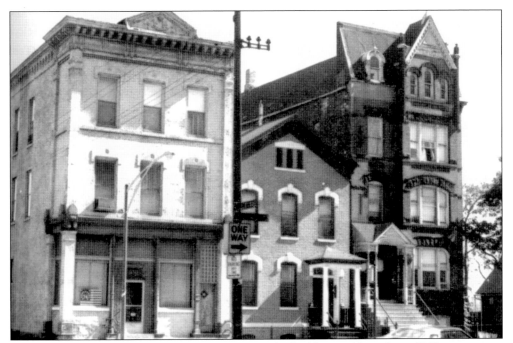

The Franciscan Sisters moved to larger quarters in the building on the right in 1902 to continue their mission. The sisters and their elderly residents lived in apartments on the first and second floors of 1368 Ingraham (now Evergreen).

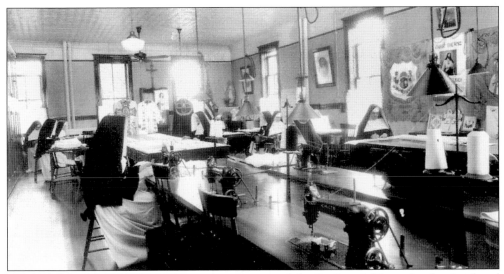

In 1897, the Franciscan Sisters began construction of the St. Joseph Home for the Aged and Crippled at Hamlin and Schubert avenues, which also served as the motherhouse for the order. In 1899, the sisters built St. Vincent Orphanage next door, which cared for over 500 dependent children until 1911, when St. Hedwig's Orphanage was opened in Niles by the Felician Sisters. One of their industries to support the orphanage was this Church Vestment Workshop, opened in 1909 on the second floor. Here the many sisters who were expert seamstresses designed, embroidered, stitched, and painted all manner of priestly vestments, altar cloths, communion veils, and processional banners and flags.

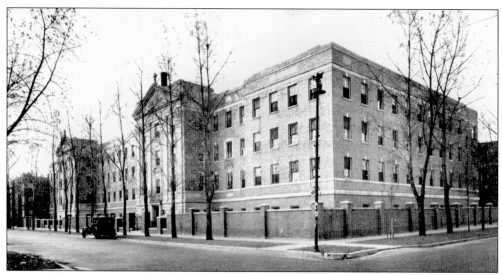

In 1928, the Franciscan Sisters built the present St. Joseph Home of Chicago, which still operates today at 2650 North Ridgeway and is seen in this photo. The architect for this structure was Joseph A. Slupkowski, with the firm of Slupkowski and Piontek, located at 1263 North Paulina. He designed several other Catholic institutional structures in Polish Downtown, including Holy Trinity High School, Francis Gordon Gymnasium, and the offices of the Polish National Alliance. The Franciscan Sisters closed the original motherhouse in their 1898 building in 1959 and built a new motherhouse in Lemont. They also operate Mother Theresa Home in Lemont, which opened in 1964 as a nursing home and senior residence.

The chapel at St. Joseph's Home contains this altar in honor of Our Lady of Czestochowa, known as the Black Madonna and revered by Poles worldwide.

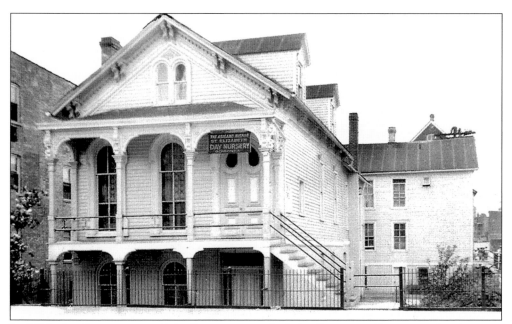

In 1904, the Congregation of the Resurrection asked the Franciscan Sisters to take charge of St. Elizabeth's Day Nursery on the southwest corner of Blackhawk and Ashland streets near St. Stanislaus Kostka. In addition to this child care center, their apostolate also included a free dispensary for the poor, a catechism center, and a home for unmarried mothers called the St. Margaret Maternity Home. St. Elizabeth's closed in 1960 and was torn down a few years later.

Sister Anne Strzelecka of the Sisters of the Resurrection opened the first Resurrection Day Nursery at 1849 North Hermitage across from St. Mary of the Angels church in 1910. It included a pre-school and boarding school and later offered classes for young women. This building had been the central home and novitiate of the Sisters of the Resurrection in America, built in 1905. It continues to operate today as the Resurrection Day Care Center.

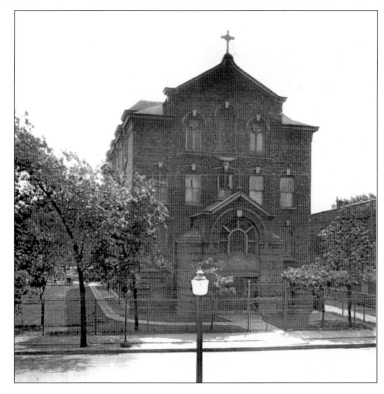

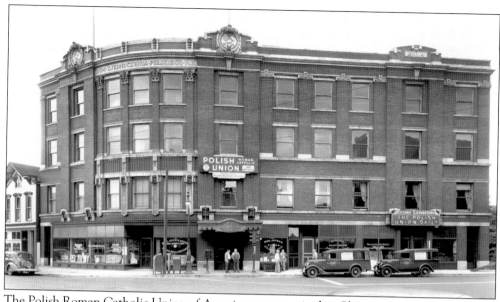

The Polish Roman Catholic Union of America was organized in Chicago in 1873 as a Catholic fraternal organization open only to Catholics. In its early years, it always remained closely connected with St. Stanislaus Kostka parish, supporting the development of an elaborate Polish parochial school system, both elementary and secondary, with seminaries and convents, the establishment of hospitals, libraries, and a network of "immigrant parish" banks. Its primary goal was to strengthen and preserve Catholicism among immigrant Poles and their future generations in America. Its historic motto is *Bog i Ojczyzna* (God and Country).

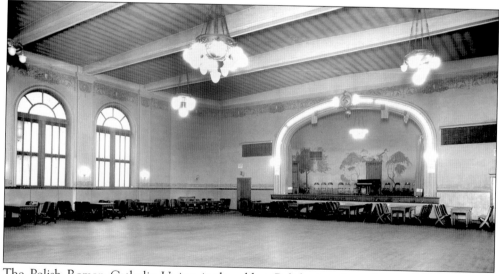

The Polish Roman Catholic Union is the oldest Polish American fraternal association in America, with over 90,000 members. It is open to all persons of Polish, Slavic, Ruthenian, or Lithuanian descent who are members of the Roman Catholic Church. It is licensed in 25 states. Benefits include life insurance, low-interest home mortgages, financial aid for college, cultural programs and classes, sports activities, Catholic traditions, and an annual Presentation Ball for young adults. This is the original auditorium of their headquarters, which is now part of The Polish Museum of America.

Four

POLISH
ORGANIZATIONS

Chicago and Polish Downtown became home to the most important Polish organizations in the country, especially the nationwide fraternal associations. Fraternals began as local mutual aid societies that could provide economic benefits and security to families in case of unemployment, illness, disability, or death. They could also offer a place to socialize with others of the same language and culture, participating in parades, celebrations, and holidays. However, these early Polish organizations began the political differences that would set the battlefield for the struggle between Polish Catholics, who placed religion above all else, and Catholic Poles, whose ethnicity directed their actions.

The first Polish association in Chicago was the Society of St. Stanislaus—Polish Catholics who gathered in the home of Anthony Smarzewski-Schermann in 1866 to plan the founding of St. Stanislaus Kostka parish. Smarzewski-Schermann is generally considered the founder of Chicago's Polonia. But within this group were dissenters who became the nucleus of the *Gmina Polska* (Polish Commune).The *Gmina Polska* was founded by Wladyslaw Dyniewicz and others to react against the religiously oriented St. Stanislaus Society. It was later absorbed into the Polish National Alliance.

By the late 1880s, the battles between these two early groups evolved into a bitter rivalry between the Unionists and the Alliancists that continued with ferocity through World War I. The Unionists' goal was to strengthen Catholicism among immigrant Poles in America. They were often led by religious clergy and regarded all others as not truly Catholic. The most prominent Unionist organization was the Polish Roman Catholic Union of America. The Alliancists were nationalists working for the liberation of Poland from its partitioning powers and the establishment of a free and independent nation. They urged American Poles to be ready to return to the homeland when freedom for Poland was secured. They were led by politically conscious emigres with resentment for the conservative role of the church in Poland. They tended to be anti-clerical and regarded all others as not really Poles. The most prominent Alliancist organization was the Polish National Alliance of America.

Women were impatient that they were not permitted full membership rights in these fraternals in their own names, but only if their husbands were members. This led female activists, under the leadership of Mrs. Stefania Chmielinska, to organize their own Polish Women's Alliance (PWA) in 1898. The PWA sought to address causes of particular concern to women, including the education of children in their heritage and humanitarian services for oppressed peoples in Poland. This activism pressed the male-run fraternals to respond. The Polish Roman Catholic Union was the first to grant full membership to women in 1899, and the Polish National Alliance followed in 1900.

Polish organizations were not limited to the fraternals, but existed for almost every possible endeavor. The collective instinct of Poles in the practice of their religious faith extended to the creation of all kinds of religious, professional, and community societies. Once a parish was started (by a society formed specifically for that purpose), other organizations began to sprout. One type was intended to support and strengthen the prayer and religious devotion of its members. Another type was devoted to humanitarian and charitable efforts. Others were for fund-raising purposes, sponsoring bake sales, bazaars, bingo games, and raffles. And yet another type focused on arts and culture, including literary and dramatic societies and choirs. (Photographs in this chapter are from the archives of The Polish Museum of America except as noted.)

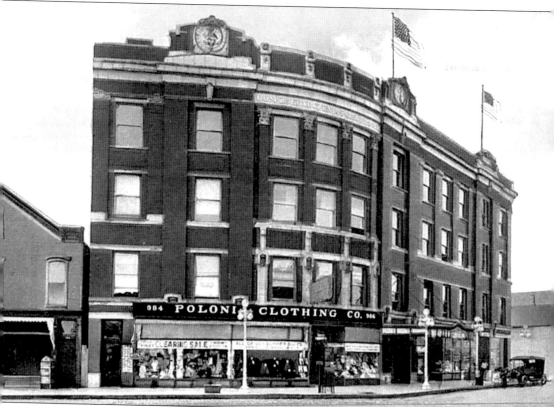

The Polish Roman Catholic Union (PRCUA) is located in this building at 984 North Milwaukee Avenue, designed by John S. Flizikowski in 1912, and is the only nationwide fraternal still located in Polish Downtown. It has a long history of publishing with its first journal, the *Gazetta Polska Katolicka* (*Polish Catholic Gazette*) originally published in Detroit but moving to Chicago in 1875. Today the PRCUA publishes the semi-monthly *Narod Polski* (*Polish Nation*). (Collection of the author.)

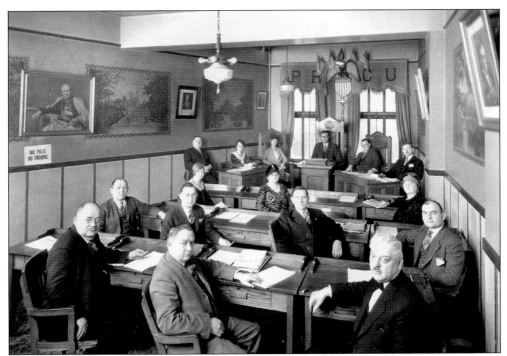

The Officers and Board of Directors of the Polish Roman Catholic Union are assembled in the board meeting room in 1930. The president from 1928-1934 and 1941-1946 was Jan J. Olejniczak. His editorial column in *Narod Polski* reported on activities of the association and he often appeared in newspaper cartoons soliciting contributions for food for the needy during the Depression.

From its founding, the PRCUA embodied a concept of Polishness that gave loyalty to family, community, and parish. Its first goals were to build Polish churches and schools, to support Polish culture and Roman Catholicism, to provide fraternal assistance to Poles, to take care of widows and orphans, and to support a Polish nation. The emblem of the organization reflects its motto, "For God and Country." Above the American and Polish flags, the bleeding heart symbolizes the Sacred Heart of Jesus, patron of the organization. Below the flags, the white Polish eagle on a red background represents country. The words around the circle state the broad goals of the association.

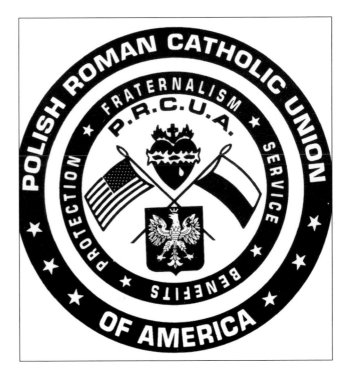

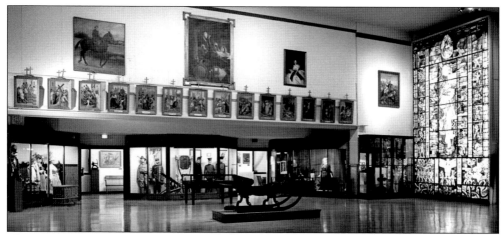

The Polish Museum of America was established by the Polish Roman Catholic Union under the presidency of Joseph L. Kania, president from 1934–1941 and 1946–1953. It purchased artifacts from the Polish Pavilion at the 1939 World's Fair in New York when the outbreak of World War II meant the collection could not be returned to Poland. Included is a large stained glass window by Mieczyslaw Jurgielewicz depicting events in recent Polish history. The Stations of the Cross hanging along the balcony are from the church in the oldest permanent Polish settlement in the United States founded in Panna Maria, Texas, in 1854.

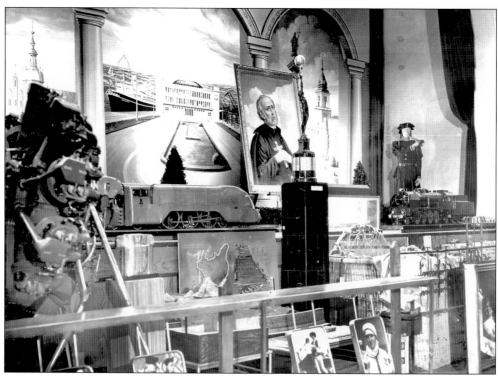

Officially dedicated on January 12, 1937, the primary purpose of the Polish Museum has been to preserve the Polish past in America and promote Polish history, culture, and traditions. Located in a section of the Polish Roman Catholic Union (PRCUA) building, it became a separate non-profit organization in 1971 but the PRCUA remains its primary source of financial support.

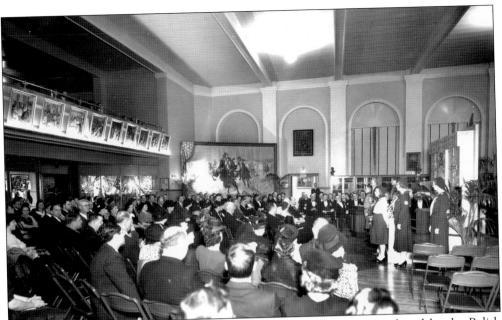

The painting of "Pulaski at Savannah" by Stanislaw Batowski was purchased by the Polish Women's Alliance, who donated it to the Polish Museum at this ceremony in 1940.

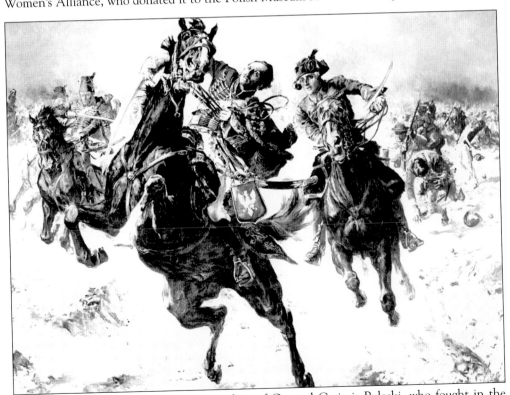

"Pulaski at Savannah" depicts the wounding of General Casimir Pulaski, who fought in the Revolutionary War for American Independence. This painting was exhibited and won first place at the Century of Progress Fair in Chicago in 1933.

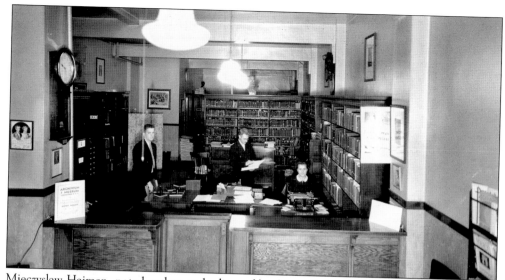

Mieczyslaw Haiman, noted author and editor of books on Polonia in both Polish and English, was the first curator of the Polish Museum. His 600-page history of the Polish Roman Catholic Union on its 75th anniversary was published by them in 1948 in Polish, against Haiman's wishes. He believed that if it were in English it would be accessible to a younger generation of American Poles. He won many literary awards, including Silver Laurels of the Polish Academy of Literature, Literary Award of the Alliance of Poles Abroad, and Living Catholic Authors. He is in the center of this photo. To the left is Edmund L. Kowalczyk and to the right is longtime librarian, Sabina Logisz, who recently retired after 67 years of service to The Polish Museum of America.

As president of the Polish Roman Catholic Union, Joseph Kania proposed the establishment of the Polish Museum in 1935. He was its guiding force, providing the authority, leadership, and financial backing needed to make it a reality. Kania was decorated by the Polish government with the Officers Cross "Polonia Restituta."

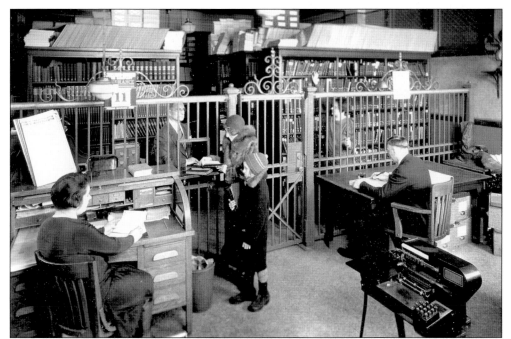

The archives of the Polish Museum contain paintings, documents, maps, coins, and artifacts relating to the history of Poland and Polonia. Included are 265 maps, the oldest one of Krakow in 1493, 730 Jubilee books from Polish Roman Catholic parishes, rare Polish books from the 16th to 18th centuries, recruitment records of volunteers in the Polish Army in France in World War I, and important collections on Kosciuszko, including his personal cup and bowl. This is the library in 1935. It is still open to the public today and is widely used by the Polish Genealogical Society of America and others.

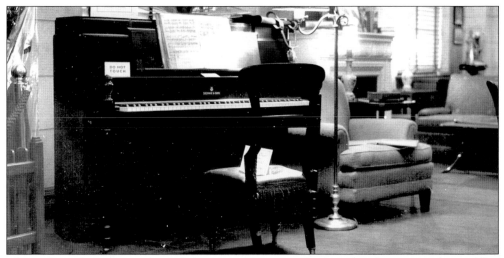

The Paderewski Room at the Polish Museum contains the largest collection in the world of the memorabilia of Ignacy Jan Paderewski, Polish patriot, statesman, and world famous concert pianist. Also included are a specially constructed Steinway piano, the last one he played, a pen with which he signed the June 28, 1919, Treaty of Versailles, and the entire suite from the Buckingham Hotel in New York, where he died in 1941.

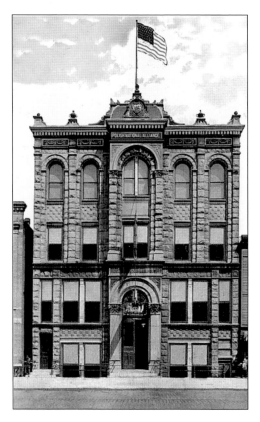

The Polish National Alliance (known in Polish as the *Zwiazek Narodowy Polski*, or ZNP) was formed in 1880 in Chicago and Philadelphia. Its first Chicago headquarters were located in this building at 1406 West Division Street, which was dedicated in 1896. (Collection of the author.)

The historic motto of the Polish National Alliance is *W Jednosci sila, w zgodzie potega* (In unity there is strength, in consensus, power). The emblem was adopted from the January 1863 uprising in Poland against Russia. It features a shield showing an eagle, a knight on horseback, and the Archangel Michael, symbolizing Poland, Lithuania, and Ruthenia, the three main regions of the old Polish commonwealth. Above the shield are two hands clasped in a symbol of fraternal cooperation.

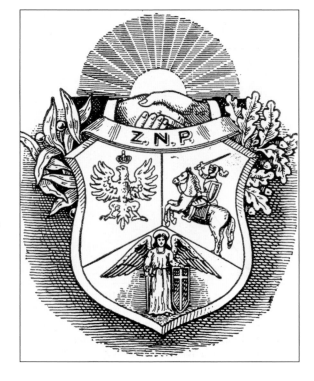

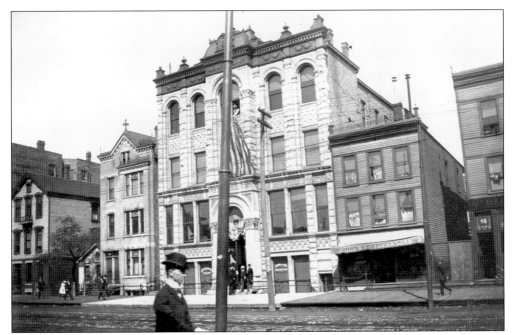

The founding goals of the Polish National Alliance were to aid the cause of Polish independence and to assist Polish American immigrants to enter the mainstream of American society. The association has spent money for various charitable and patriotic purposes, including scholarships, Polish schools, the Falcons, Scouts, the resettlement of refugees, naturalization of immigrants as citizens, and relief assistance to the people of Poland. This photo shows its location on the north side of Division Street in 1901.

The headquarters of the Polish National Alliance (PNA) were at 1406 West Division Street for 40 years, from 1896 through 1936. With the outbreak of World War I in 1914, the PNA joined forces with other organizations to form the Polish Central Relief Committee to collect money and material goods for people in war-ravaged Polish lands. This gathering is a patriotic manifestation with World War I army veterans and Polish scouts from the 1930s.

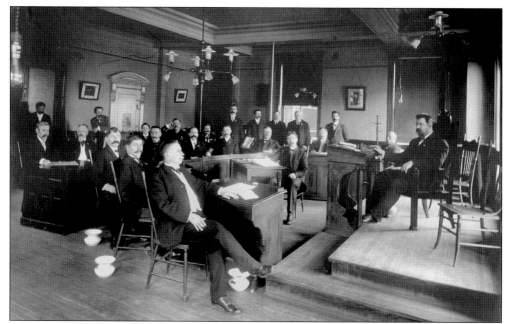

The Polish National Alliance (PNA) was one of the strongest supporters of Polish independence during World War I, a goal realized for just over 20 years, until Germany invaded Poland in 1939. The nation of Poland had been wiped off the map of Europe for over 120 years, from 1795 through 1918, when it was partitioned between Prussia, Russia, and Austria. This is a meeting within the offices of the PNA in 1905.

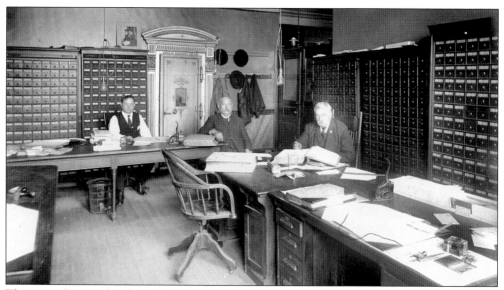

These are the membership offices of the Polish National Alliance (PNA) in 1905. Today the PNA is the largest of all ethnically based fraternal insurance benefit societies in the country. It has over 300,000 members with some in every state in the United States, and 916 local lodge groups. Its membership has always been open to Jews and other non-Catholics. It offers life insurance, college scholarships, orphans' benefits, low interest home mortgages, cultural classes, and sports activities, and seeks ways of assisting new entrepreneurs in Poland.

The Polish National Alliance donated funds for the Thaddeus Kosciuszko monument, which was unveiled in Humboldt Park on September 11, 1904. An estimated 100,000 Poles were in attendance. The monument was often the rallying point for many Polish parades, events, and demonstrations. Representatives of all Chicago's Polonia dedicated this wreath on February 12, 1946. The monument was relocated to Solidarity Drive near the Planetarium in 1978.

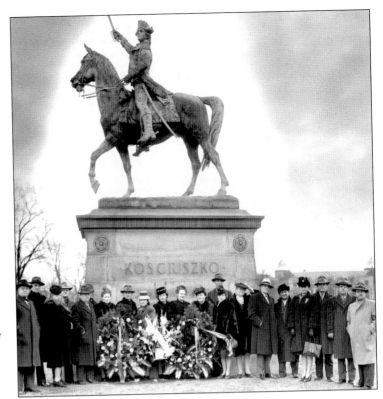

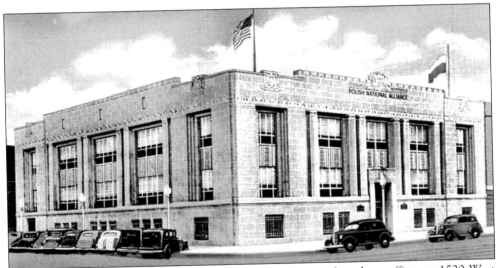

On May 7, 1938, the Polish National Alliance (PNA) moved to these offices at 1520 West Division Street designed by Joseph Slupkowski. During World War II, PNA president Charles Rozmarek led the PNA to play a key role in founding the Polish American Congress (PAC), a nationwide federation to continue working toward the freedom of Poland. After 50 years of effort, this goal was finally achieved in 1989 with the end of Soviet occupation and the collapse of the communist dictatorship. Throughout its history, the PAC has been headed by the president of the PNA. The PNA relocated from Polish Downtown to 6100 North Cicero Avenue in 1976. (Collection of the author.)

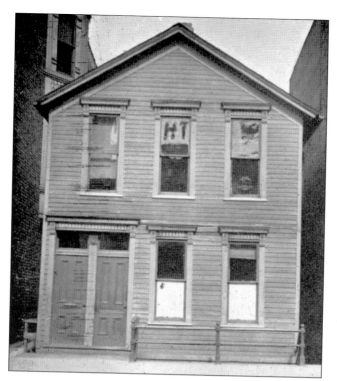

The Polish Women's Alliance (PWA) (known in Polish as the *Zwiazek Polek w Ameryce* or ZPA) was founded in 1898 in Chicago by Stefania Chmielinska, a Polish immigrant and seamstress. It is one of the oldest fraternal benefit societies founded and run by women at a time when women did not yet even have the right to vote. After meeting for several years in private homes, the PWA purchased this frame house near Milwaukee on Ashland Avenue and opened there on February 26, 1905. They modified the first floor for a hall and the second floor was used for offices.

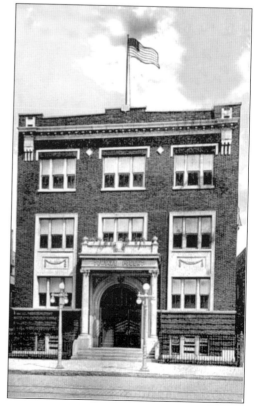

The goal of the Polish Women's Alliance has been to help women become financially secure and economically independent through education, better employment, and insurance benefits. The organization has also been active in aiding and supporting the cause of freedom for the Polish nation and providing relief for its people in time of war. Larger quarters were soon needed, so groundbreaking for this structure at 1309 North Ashland Avenue occurred on August 18, 1911. (Collection of the author.)

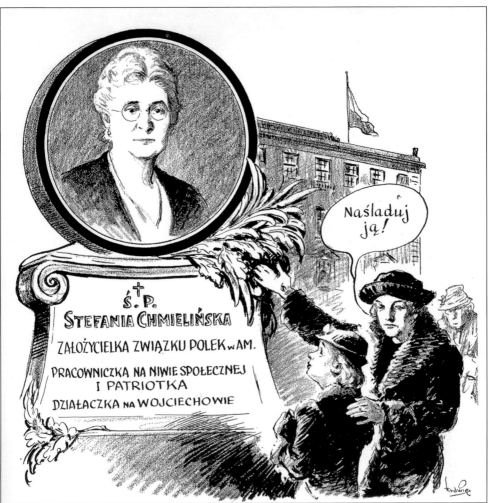

The first president was Mrs. Stefania Chmielinska, who believed deeply in the cause of women's equality. She and the founding members of the Polish Women's Alliance fought for the rights of women to attain higher education, enter many professions, and purchase life insurance in their own names. Chmielinska was awarded the Gold Cross of Service in 1939 by the Polish government for her efforts on behalf of Poland and the improvement of conditions for Polish immigrants in America. The inscription on this cartoon reads "Founder of the Polish Women's Alliance, Social Welfare Worker, and Patriot, active at St. Adalbert's Church." The mother on the right is telling her daughter to follow Chmielinska's example.

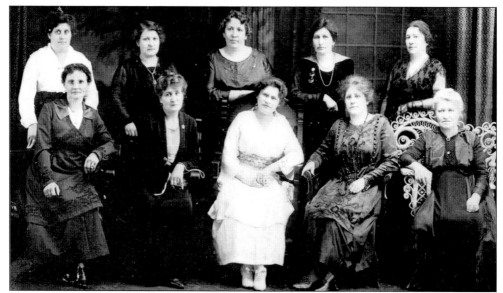

The Polish Women's Alliance (PWA) sought to address causes of particular concern to women, including the education of children in their Polish heritage and the provision of humanitarian services for Poland. Emilia Napieralska was the PWA's first American-born president, serving from 1918-1935. She played a leading role in the 1916 International Women's Peace Conference and led the efforts to rename Pulaski Avenue in Chicago after General Casimir Pulaski, the "Father" of the U.S. cavalry. She is seated in the center of the first row in this photo of the PWA officers at the 1921 convention in Chicago. Stefania Chmielinska is to the left of her.

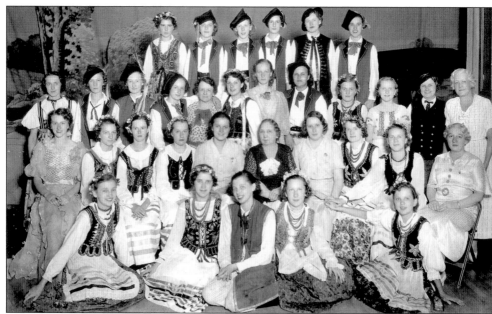

Annual conventions, most held in Chicago, were considered great occasions. They always opened with a solemn church service. The Polish Women's Alliance was interested in fraternal, humanitarian, social, cultural, and patriotic activities. This dance group in Polish costumes is from 1936. President Honorata Wolowska is seated in the center with the dark dress and white scarf.

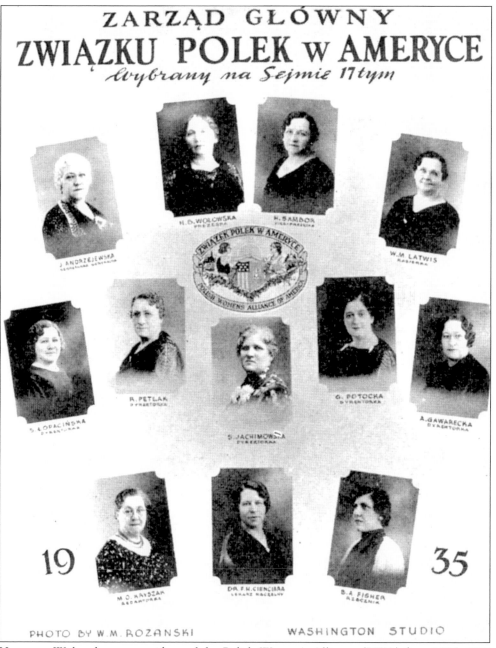

Honorata Wolowska was president of the Polish Women's Alliance (PWA) from 1935–1947 during World War II. She led the organization's humanitarian efforts in delivering tons of food, clothing, and medical supplies to Polish war victims. She also helped found the Polish American Congress, a political action federation, in 1944. These are the PWA officers during the 17th convention, held in 1935. The emblem of the organization can be seen in the center.

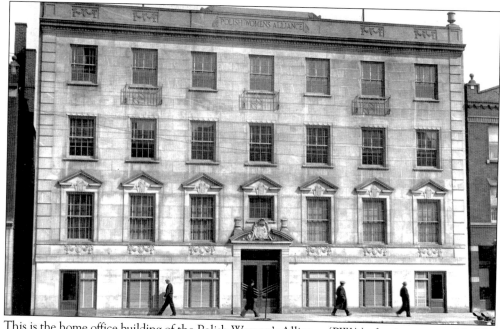

This is the home office building of the Polish Women's Alliance (PWA) after it was remodeled for the first Polish Women's Congress in 1933, which attracted delegates and guests from all parts of the United States and from Poland. Today the PWA is located at 205 South Northwest Highway in Park Ridge, Illinois, and is the largest Polish women's fraternal insurance body in the world. It offers life insurance, scholarships, and social, cultural, and civic activities for members of all ages and continues to publish a monthly newspaper, *Glos Polek* (*The Polish Women's Voice*).

The first lodge, or nest, of the Polish Falcons of America was founded in Chicago in 1887. A physical fitness organization, it was modeled after a similar organization that had developed in the German-occupied part of Poland in 1867. In 1894, 12 nests around the United States were incorporated into a national organization headquartered in Chicago under the name Alliance of Polish Turners. This building at 1062 North Ashland Avenue was purchased by Nest #2 in 1920. Nest #2 had been founded on January 31, 1892, in the hall of Antoni Groenwald on Greenview Avenue. After World War I, as membership in the Falcons declined, Nest #2 merged with Nest #189 under the name *Im. Wlodzimierz Swiatkiewicz* and renovated this building as a center of Polish culture. It was dedicated in May 1922 by Rev. Sztuczko. This photo dates from 1942.

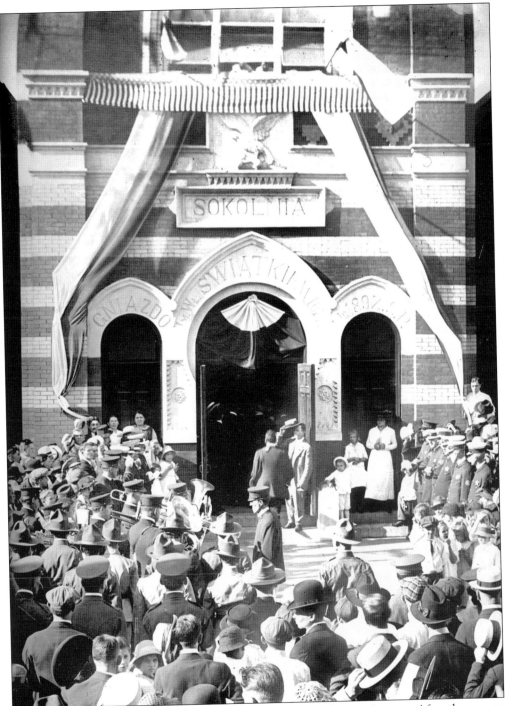

This is the gymnasium hall of Falcons Nest #189 at 1516 Thomas Avenue. After the merger with Nest #2, this building was used for a short time as a home for returning soldiers. It is now a private home.

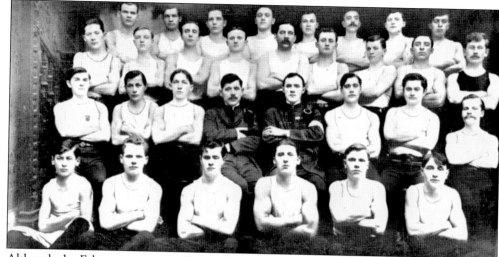

Although the Falcons were originally founded to develop strength through gymnastics, physical exercise, and supervised sports, between 1905 and 1912 differing opinions of the role of the organization led to a split. When reunified, the corporate name became Alliance of Polish Falcons of America and its purpose was amended to "exert every possible influence towards attaining political independence of the fatherland." These young men are a squad of trainees from 1912.

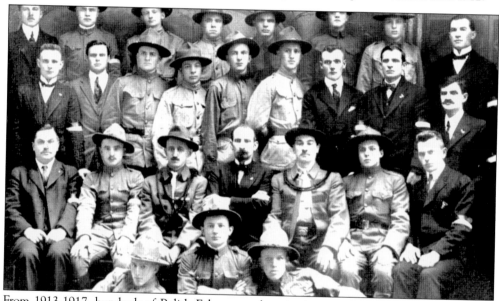

From 1913-1917, hundreds of Polish Falcon members in America were given military training and eventually fought in World War I for the liberation of Poland in the Polish Army of France under Gen. Joseph Haller and the US Armed Forces. When the United States entered the war in 1917, there were 12,000 trained Falcons ready to answer President Woodrow Wilson's first call for volunteers. Five thousand others joined the Polish Army in France, first proposed by the Polish pianist Ignacy Jan Paderewski and organized under special decree of the President of France. The American government later authorized the recruiting of volunteers in America for this army and one of the recruiting centers was at the Polish Roman Catholic Union of America offices on Milwaukee Avenue. Twenty-two members of Nest #2 joined the U.S. Army and 95 members joined the Polish Army, including one woman. These are some of the members of Nest #2 in 1918.

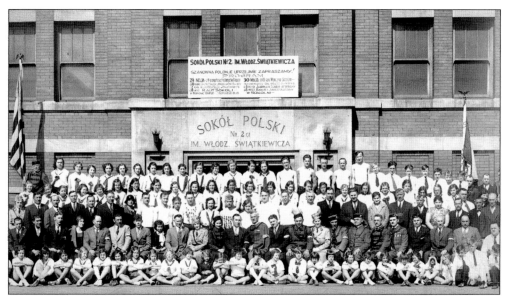

Between the world wars, the Falcons resumed their emphasis on physical training, participating in gymnastic meets and athletic competitions across the country. This is a group organized for the 40th Jubilee of the Falcons in May 1932, in front of the hall on Ashland Avenue. This building was sold in 1970, but monthly meetings continue at the Copernicus Center. Today, the organization holds the tradition in which it was originally founded, to provide athletics and physical fitness training for its members throughout the country.

The falcon is a daring and fearless bird known for its independence, strength, and defense of its domain. The Polish word for falcon is *sokol*. The symbol of the organization was altered in 1914 from a falcon clutching a barbell in its claws, to the same falcon, now breaking a chain around its claws with a rifle and bayonet crossed behind it. The branch on the left signifies the laurels of victory. Behind the falcon is the burial mound of Kosciuszko, patron of the Falcons. The motto means "Salute to the country; claws at the enemy."

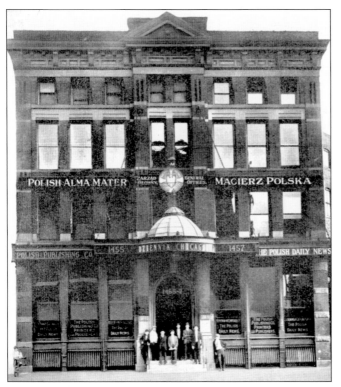

The Polish Alma Mater (*Macierz Polska*) was organized by Rev. Francis Gordon in 1897 as a social group for young men under clerical leadership. Its goals were to preserve Polish heritage and the Catholic faith among young people. It had a cadet corps, choir, and athletic teams, and began to admit women in 1901. Eventually it grew into a nationwide fraternal and, like the larger ones, began selling life insurance. The headquarters of the organization was first located at 1455 West Division Street, in the same offices as the Polish Publishing Company. Rev. Gordon was also the publisher of the newspaper *Dziennik Chicagoski* for many years.

The Polish Welfare Association was founded in 1922 by members of the Chicago Society of the Polish National Alliance, with its initial purpose to address the problem of juvenile delinquency among Polish youth who were not adjusting well to urban life in America. Their first offices were on Michigan Avenue, and then several other locations on Milwaukee Avenue until moving to this storefront at 1303 North Ashland Avenue in 1955. Satellite offices were located in Polish neighborhoods throughout Chicago to provide services.

The cover of this program booklet from 1943 illustrates one of the concerns of the organization known today as the Polish American Association: the care of needy families. The association provides a wide variety of social services, including literacy programs and English classes, employment counseling and job placement, youth outreach, substance abuse treatment programs, services for the homeless, for the disabled, and for the elderly, immigration and citizenship services. They publish a newsletter, *The Link*. The main offices are now at 3834 North Cicero Avenue.

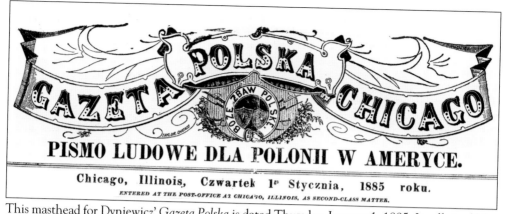

This masthead for Dyniewicz' *Gazeta Polska* is dated Thursday, January 1, 1885. It calls itself the *Peoples' Newspaper for Poles in America* (*Pismo Ludowe dla Polonii w Ameryce*).

Publisher Wladyslaw Dyniewicz was born in Poland and came to Chicago in 1867. Not only was he the publisher of the first Polish paper in Chicago, the weekly *Gazeta Polska*, his publishing company also reprinted and sold thousands of Polish books. This photo was taken on the occasion of his 50th wedding anniversary to Albertyna, on January 17, 1913. Dyniewicz died in 1928.

Five

THE POLISH PRESS

The Polish press has been a long-standing tradition since the first days of Polish settlement on Noble Street in the 1870s. Polish publishers of newspapers, books, theatrical works, and textbooks flourished here from the 1890s through World War I. The first Polish-language weekly newspaper was Wladyslaw Dyniewicz' *Gazeta Polska*, begun in 1872–1873, with offices on Noble Street in the heart of the Polish business area. This paper was popularly known as the *Dyniewiczowka* after its publisher, whose passionate opinions on the cause of Polish nationalism filled the editorial pages.

The first paper on the other side of the Alliancist/Unionist divide was the *Gazeta Polska Katolicka* or *Polish Catholic Gazette*, a weekly founded in 1874 by Rev. John Barzynski, brother of Rev. Vincent Barzynski. By 1887, the Barzynskis and Rev. Francis Gordon, with Wladyslaw Smulski, founded the Polish Publishing Company to produce Catholic literature in Polish. Their veiled purpose, however, was to wage war with the Alliancist publications of Dyniewicz. Their *Wiara i Ojczyzna*, or *Faith and Fatherland* weekly was the first published in conjunction with the Polish Roman Catholic Union. To further promote the parish/community complexes of the Resurrectionist priests, they began publishing the *Dziennik Chicagoski* in 1890, popularly known as the *Polish Daily News*.

The two ever-battling fraternals, the Polish Roman Catholic Union and the Polish National Alliance, started various weeklies and dailies in the late 1800s in their ceaseless efforts to capture the minds and hearts of local Poles. In fact, those organizations are responsible for most Polish publications, using them to reinforce their position with members and spread it to non-members. After a while, some dealt primarily with organizational issues and positions, while others developed into general information papers. The Polish National Alliance was responsible for the *Zgoda*, or *Harmony*, a weekly house organ started in 1881, and the *Dziennik Zwiazkowy*, or *Alliance Daily News*, started in 1908. Both were published by Alliance Printers and Publishers, once located in the heart of Polish Downtown, and both are still published today.

The Polish Roman Catholic Union published the *Dziennik Zjednoczenia* or *Union Daily News* from 1923 to 1939, and the *Narod Polski* or *Polish Nation*, a weekly begun in 1897. Its longtime editor was Sigmund Stefanowicz. The *Narod Polski* is still published as a semi-monthly in English and Polish as the official members' publication for the organization.

Newspapers were just a part of the early Polish press. The steady flow of immigrants fueled the demand for the works of popular Polish authors such as Henryk Sienkiewicz and Adam Mickiewicz, whose works of fiction and poetry were being reprinted and distributed to communities across the United States as part of a huge mail order business. Polish books could be found in almost every Polish home. For the working classes who couldn't read well, groups would gather for readings of popular literature by a more fluent reader. The proliferation of

local literary societies and dramatic circles who regularly staged Polish theatrical works also fed the publishing demand. Not only the great traditional Polish authors, but aspiring local talent as well, could get their works published and performed in Polish Downtown. Yet another market for Polish publishing was found in the schools and parish libraries, which needed textbooks, dictionaries, and handbooks of various kinds. Although the Polish press shrank after the Depression, it prevailed, so that today, one can still find two daily newspapers, weekly and monthly magazines, organizational publications, and books of many kinds published in Chicago in the Polish language. (Photographs in this chapter are from the archives of The Polish Museum of America except as noted.)

Printing of Polish textbooks was a large part of the Polish press. Although this is a second grade reader, Catholic imagery is featured throughout. The cover says *My Second Booklet*. This particular book was printed at St. Hedwig's Printery in the Polish orphanage. (Collection of the author.)

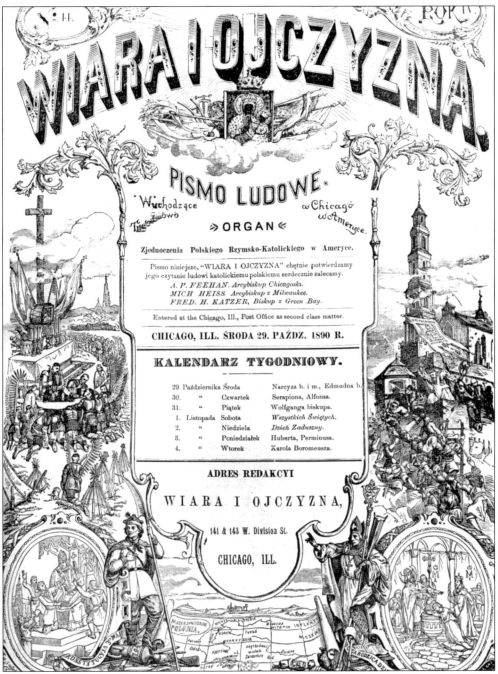

Wiara i Ojczyzna or *Faith and the Fatherland* displays the Catholic side of the publishing battles and also claims to be a peoples' newspaper. A weekly put out by the Barzynskis as the house organ of the Polish Roman Catholic Union (PRCUA), this cover is full of religious images, with a map of Poland at the bottom. There is a calendar (*Kalendarz*) in the center that lists the religious feast days for the week beginning with Wednesday, October 29, 1890. This paper served as the official paper of the PRCUA until 1897, when the PRCUA began publishing its own *Narod Polski*.

DZIENNIK CHICAGOSKI
THE POLISH DAILY NEWS

SOBOTA, DNIA 7-GO GRUDNIA, (SATURDAY, DECEMBER 7), 1940 ROKU

TEL. BRUNSWICK 7040

This front page from the December 7, 1940, issue of *Dziennik Chicagoski* commemorates the paper's 50th anniversary. The warrior with a shield emblazoned with the name of the newspaper is protecting a woman and her children. The inscription within the clothing of these figures reads "Faith, Hope, Charity."

The Polish Publishing Company founded by the Revs. Barzynski and Gordon was located in this building at 1455-1457 West Division Street, which also housed the Polish Alma Mater organization for over 50 years. Its stated principles have been the interests of the Catholic faith, the struggle for the independence of Poland and subsequent restoration to the family of nations, and the civic progress and advancement of Poles in America, specifically Chicago. The *Dziennik Chicagoski*, or *Chicago Daily News*, the second oldest Polish daily newspaper in America, began publication here in 1890 and was published until 1971. Although it supported the Polish Roman Catholic Union and often printed its news, it was never its official paper. A paper with a similar name, *Dziennik Chicagowski*, is published today but has no link to the first *Dziennik Chicagoski*.

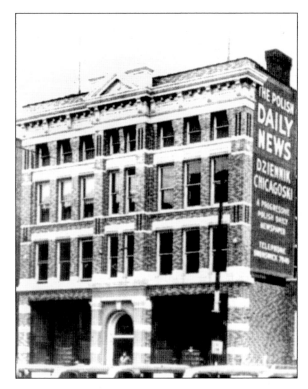

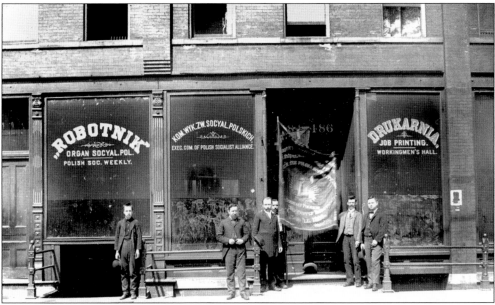

These are the offices of the executive committee of the Polish Socialist Alliance in 1902. They published a socialist weekly paper called *Robotnik*, or *Worker*. The socialist press was not large in the Polish immigrant community but there was one daily paper, the *Dziennik Ludowy* or *People's Daily*, published in Polish by the American Socialist Party from 1907–1924. Its circulation was 20,000 nationwide at its peak in 1920, but it was too anti-clerical to be very popular among the fervently Catholic Poles.

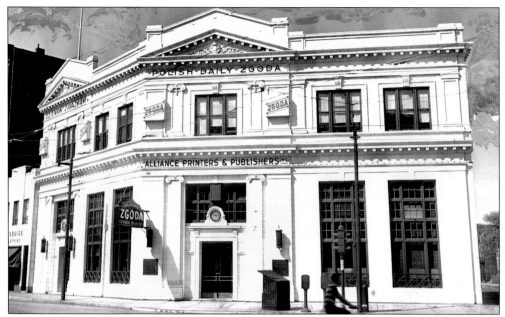

Both Polish National Alliance publications, the *Zgoda* and the *Dziennik Zwiazkowy* (*Alliance Daily News*), were published at Alliance Printers and Publishers at 1201 North Milwaukee Avenue. This building was designed by John Flizikowski and built in 1920 for the second Northwestern Trust and Savings Bank, founded by John Smulski. It was dedicated as the home of the *Zgoda* on October 31, 1942, by Rev. Sztuczko.

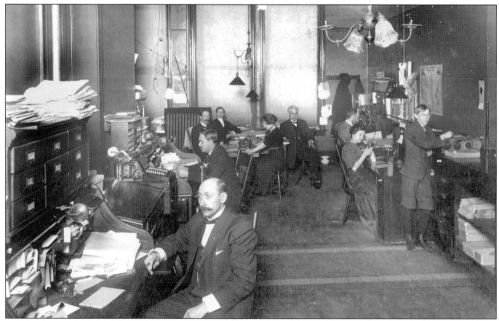

The Polish National Alliance (PNA) started its first newspaper, the *Polish Daily Zgoda* (*Harmony*), in 1881 to promote PNA objectives. Its publication was moved to Chicago in 1888. It continues today as a biweekly publication in English, informing its members about the heritage of Poland. The editorial staff of the *Zgoda* are shown here in their offices in the early 1900s.

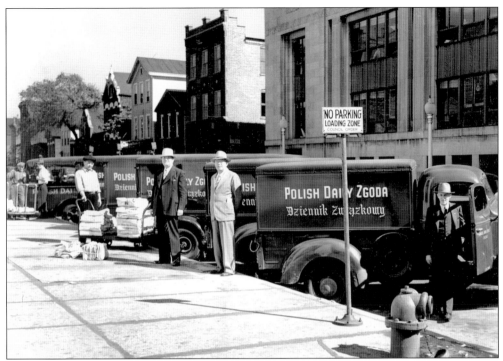

These delivery trucks for the *Zgoda* and *Dziennik Zwiazkowy* are parked on North Greenview Avenue behind the offices of the Alliance Printers and Publishers. The photo is dated September 26, 1946.

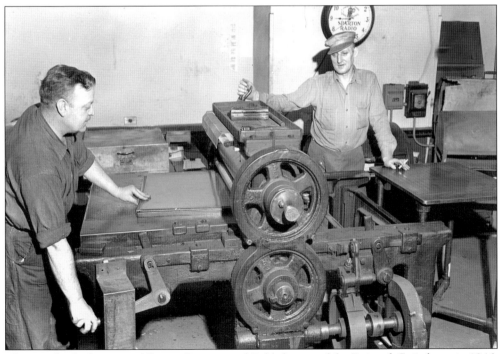

This is a flat-bed press at Alliance Printers and Publishers used for *Dziennik Zwiazkowy* in 1946.

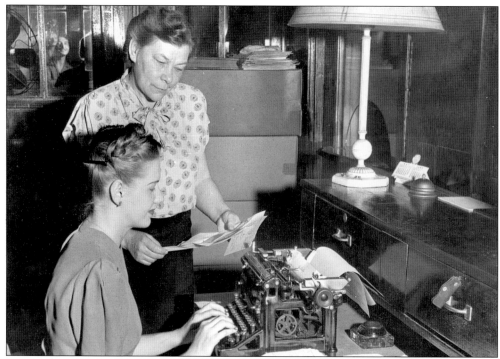

These women are working in the administrative offices of Alliance Printers and Publishers in 1946.

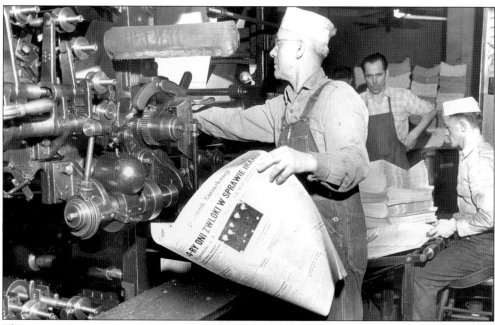

This pressman at Alliance Printers and Publishers has just pulled a 1946 issue of *Dziennik Zwiazkowy* off the presses. The Polish National Alliance (PNA) began publishing this daily newspaper in 1908, and it is still published today as *The Polish Daily News*. The PNA has also owned, managed, and operated a radio station in Chicago since 1987 known as WPNA Radio–Chicago (1490 AM).

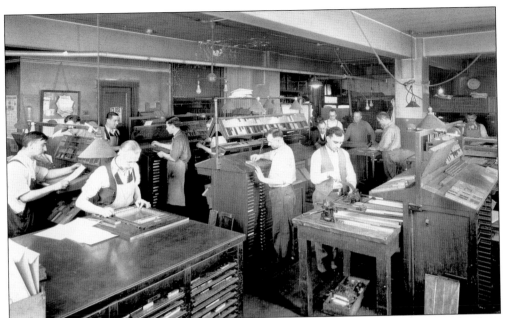

A series of photographs from February 1929 by the noted architectural photography firm, Kaufmann and Fabry, documents many aspects of the publishing operations of the Polish Roman Catholic Union. This is the typesetting room for the *Dziennik Zjednoczenia*. Typesetting for display pages, particularly large headlines, was done by hand, placing individual letters in rows on flat metal beds.

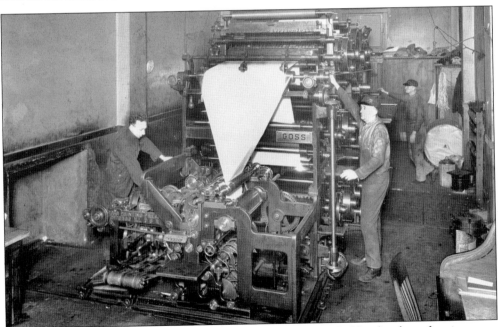

These are the presses for the *Dziennik Zjednoczenia* (*Union Daily News*), whose first issue was printed in September 1921. The paper began having circulation problems in 1934 and the Polish typographers even agreed to forgo an increase in wages in 1935. But the paper kept losing money and publication was stopped in 1939.

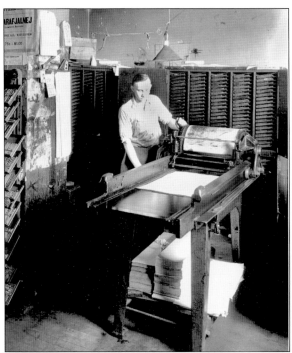

This is a flat bed printer at the *Dziennik Zjednoczenia*, which makes impressions by paper rolling across a metal drum. The *Dziennik Zjednoczenia* frequently serialized novels such as those by Henryk Sienkiewicz in its editions.

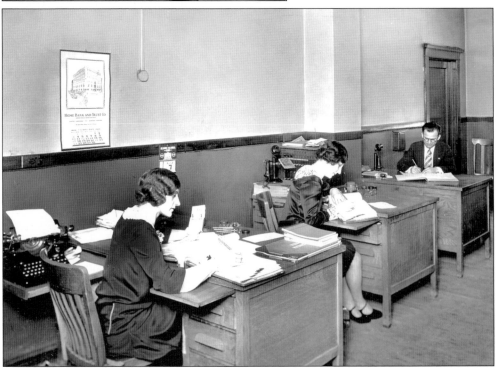

These are the administrative offices of the *Dziennik Zjednoczenia* in 1929. This paper was more news-oriented than the Polish Roman Catholic Union's *Narod Polski*. Although it took a firm Polish Catholic position on the issues of the day, it was always clearly the voice of an organization run by Polish Catholic laypeople.

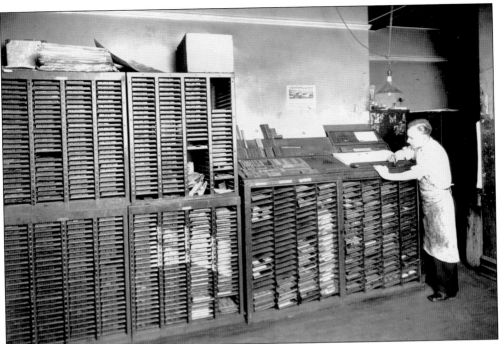

There were over 6,000 subscribers to the *Dziennik Zjednoczenia* worldwide in 1933, and metal plates with the addresses stamped on them were kept in boxes in this cabinet. The paper was printed in two editions: one for the Chicago area with more local advertising, and a second for the rest of the world.

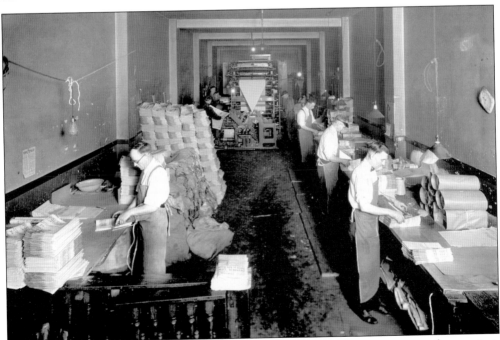

These men are stacking and wrapping newspapers for distribution. The paper was sent free to priests and nuns across the United States and to other countries, including Poland, Brazil, and China.

Wladyslaw Kloski's Inn was located at the southeast corner of Noble and Division streets, as seen in this 1890 photo. The awning identifies this as the Headquarters of the Kosciuskio Guards. Few of the early frame storefront buildings such as these are still standing on Noble Street today, and those that are have had the ground floor space converted to residences.

The Anton Schermann Tourist Bureau was started by Anthony Smarzewski-Sherrmann in 1868 and was the site of the first Polish Roman Catholic Union Convention in 1874. Smarzewski-Schermann was born in Poland in 1818, came to Chicago in 1851, and is considered the first permanent settler and founder of Chicago's Polonia. Through his business he brought over 100,000 immigrants to the United States.

Six

POLISH BUSINESSES

The principal trading center of Chicago's Polish community beginning in the 1870s was Noble Street. Linking St. Stanislaus and Holy Trinity churches, those three blocks were lined uninterruptedly with individual narrow, frame and brick storefront buildings, typically housing apartments on the upper floors. These structures were suitable for the many types of small businesses run by Poles. Most common were those offering a variety of foods: retail groceries, meat markets, delicatessens, creameries and dairy stores, and confectionaries. In small, industrial-type buildings on the rear of these lots could be found bakeries and sausage-makers whose products would be sold in the front store. There were also several drug stores, cigar shops, and many *bufets*. The *bufets* served cooked food, catering to the many residents who lived in extra rooms in peoples' homes. Undertakers were scattered throughout the community to serve the two parishes. The other residential streets between Noble and Ashland, such as Cleaver, Greenview, and Blackhawk, were not exclusively residential, but also had storefront buildings scattered in between. The storefront buildings fit in well in the neighborhood because the only real difference in the way they looked was that the storefronts had their first floors at ground level and were built right up to the sidewalk, while the residential buildings were set back from the street just enough for a short staircase leading to a raised first floor. Walking up and down these streets today, it's easy to pick out which were once storefronts even though they've all been converted to residential.

In 1911, the creation of Pulaski Park, although an important asset for this immigrant, working class community, dealt a serious blow to the viability of the north end of the Noble Street commercial district. Located on the 1300 blocks of Noble and Cleaver streets, it caused the demolition (or relocation in some cases) of 90 structures and the displacement of 1,200 people, wiping out an entire long block of local businesses. By the 1910s, many Polish establishments had dispersed from their origins on Noble Street, moving west into larger, existing commercial buildings on Milwaukee, Division, and Ashland avenues. Many of these buildings had been built by German Americans who resided in adjacent neighborhoods south and west of the commercial streets.

There has always been a strong preference for Poles to invest in real estate. Census statistics show homeownership rates for Poles much higher than for Chicago's population overall. Perhaps this is because in Europe the land they occupied was not their own—it was ruled by foreign sovereignties. Polish immigrants, upon arriving in this country, began immediately to organize building and loan associations where they could systematically save their money each week with an eye toward amassing enough for a down payment on their own property. The earliest lending institutions were loan associations connected with the Polish parishes. The first of these was the *Bank Parafialny* (Parish Bank), created by Rev. Barzynski for his parishioners

at St. Stanislaus Kostka in 1875. From this start, many Polish building and loan associations were founded, with some in the neigbborhood, including Polish Crown at 1372 Evergreen and Pulaski Building & Loan at 1313 Noble Street. By 1937, there were 30 Polish building and loan associations in Chicago. For more complex financial needs, there was the *Bank Polski*, as it was popularly called, founded by John Smulski in 1906. Located on Milwaukee Avenue, its formal name was the Northwestern Trust and Savings Bank and it was the largest bank outside of downtown Chicago. (Photographs in this chapter are from the archives of The Polish Museum of America except as noted.)

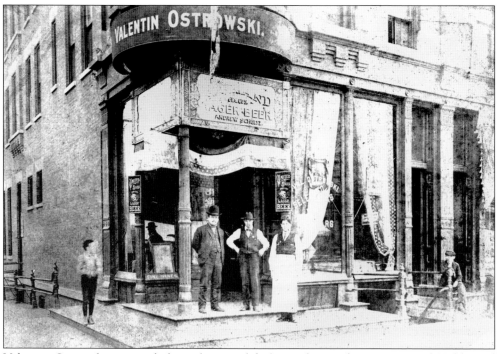

Valentin Ostrowski operated this saloon and *bufet* at the southeast corner of Noble and Blackhawk. This building is still standing today. At the turn of the century it took only about $500 to open a saloon, and immigrants often aspired to this kind of work. Polish saloonkeepers comprised over three percent of the working population and were regarded with respect within the community.

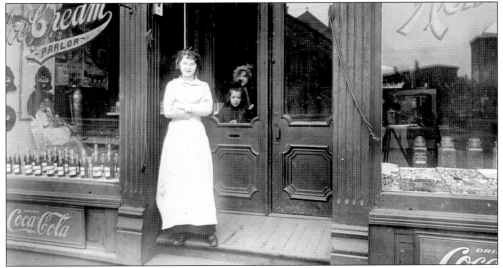

Kilinski's Ice Cream Parlor and Polish Grocery was located at Thomas and Milwaukee avenues. This photo is from about 1911. In the late 1800s, it was common for eating establishments to serve either men or women. The "ice cream and eating saloon," which would not have served liquor, was considered a safe place for women and children to eat out.

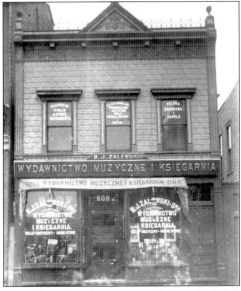

(*left*) One prominent Polish immigrant was Piotr Rostenkowski, who came to Chicago in 1886. He operated a wholesale warehouse for vodka, liquor, and wine at 1372 West Evergreen, directly across the street from St. Stanislaus church. Active in civic affairs, he served as president of the Polish Roman Catholic Union from 1913–1917, was a founder of the National Department of the Polish Central Relief Committee, and was decorated by the Polish government with the Order of Polonia Restituta. The property on Evergreen was purchased by Piotr Rostenkowski in 1912 and is still in the Rostenkowski family today.

(*right*) B.J. Zalewski Music and Book Publishers was located at 1505 West Thomas Street in 1910. The upper floor housed the headquarters of the Polish Orchestra and Band and offered music lessons in violin and other instruments.

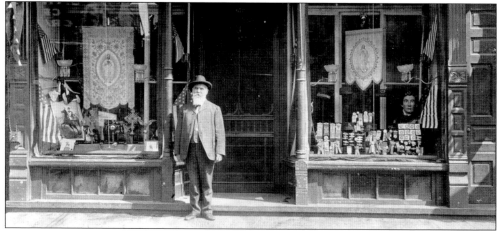

One of the older establishments was the W. Slominski Badge and Bannerworks Store at 1025 Milwaukee Avenue on the corner of Noble Street. The store opened in 1872; proprietor Wladyslaw Slominski is shown in front of his store here about 1900. After his death, the store was operated by his son-in-law, Wojciech J. Danisch.

 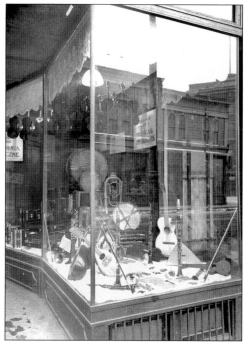

(*left*) The Slominski store designed and produced banners used in parades, festivals, and celebrations. Each organization would have a custom-designed and sewn banner identifying their group. Some of the original watercolor sketches for these banners are at the Polish Museum, signed by Mrs. Slominski. In this logo for their business, the flag on the left was an interpretation of a Polish flag, since a Polish nation did not exist at that time. It shows a Polish eagle in the center, against a background of red, white, and blue stripes.

(*right*) On display in the showroom windows of Sajewski Music Store are a variety of unusual stringed and other musical instruments. The store also offered a wide variety of published music and recordings.

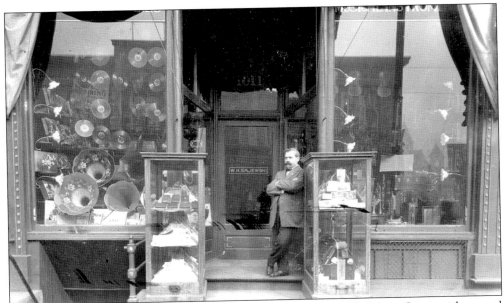

A long-standing business in the community was the W.H. Sajewski Music Store, with several locations in Polish Downtown. Founded in 1897 by Wladyslaw and Helena Sajewski, it claimed to be the oldest Polish music store in the United States. After Wladyslaw's death in 1948, the store was taken over by their son, Alvin, who had worked there since his childhood. The store celebrated its 80th year in business in 1977 but is no longer in operation today.

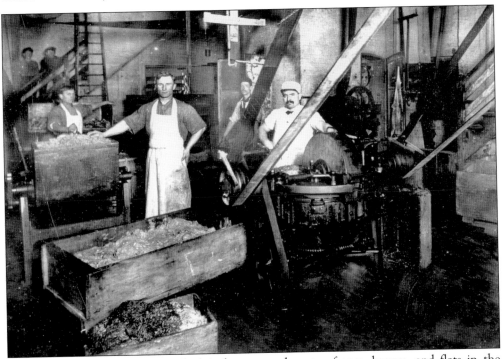

Small sausage factories were tucked in between other storefronts, houses, and flats in the neighborhood, at 1333 North Bosworth, at 1213 North Cleaver, and in other locations. This is the inside of one of those Polish sausage factories in 1902.

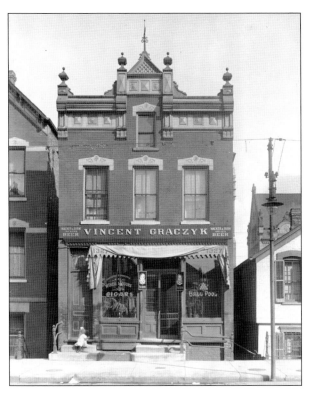

Vincent Graczyk operated this wine, liquor, and cigar store at 1327 North Cleaver. It also contained pool tables. Conflicts had begun to arise at the turn of the 19th century between social reformers who wanted to curb the influence of bars on the city's social life, and the many restaurant and saloon owners throughout the city. A $1,000 liquor license requirement enacted in 1906 forced many small establishments to close. The Graczyk building was demolished for Pulaski Park. (Courtesy of Chicago Park District Archives.)

Z. Jablonowski's store was located at 1307 North Cleaver Street in 1910. This building, built in 1889, was just over 20 years old when it was demolished for Pulaski Park. (Courtesy of Chicago Park District Archives.)

This building at 1419 West Blackhawk served as the livery for John Jarzembowski, an undertaker. The offices were around the corner at 1350 North Noble. Both structures were demolished for Pulaski Park. (Courtesy of Chicago Park District Archives.)

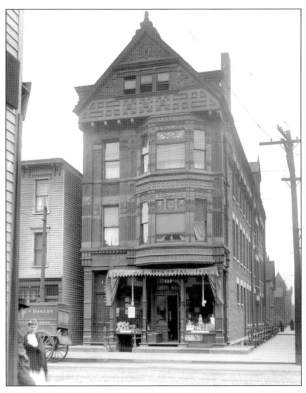

J.F. Bykowski's bakery was located at 1425 West Blackhawk. It was demolished for Pulaski Park. (Courtesy of Chicago Park District Archives.)

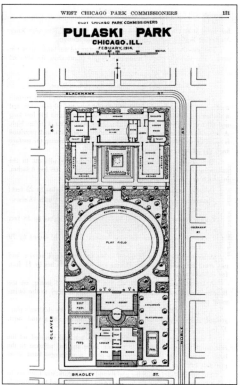

PULASKI PARK
CHICAGO, ILL.
FEBUARY, 1914.

The site plan for Pulaski Park was designed by noted landscape architect and head of the West Park Commission, Jens Jensen. The oval, slightly sunken ballfield encircled by a running track in the center of the plan was later replaced with a rectangular grass-covered area. (Courtesy of Chicago Park District Archives.)

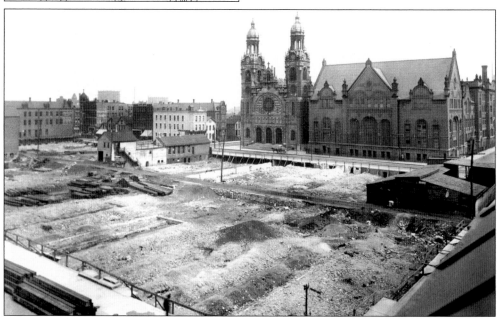

This is the site where 90 business and residential structures were demolished in 1911 to allow for the construction of Pulaski Park. The view is looking northeast from the corner of Cleaver and Potomac and shows the parish complex of St. Stanislaus Kostka in the background. Two owners opposing condemnation of their properties sued but were unsuccessful. (Courtesy of Chicago Park District Archives.)

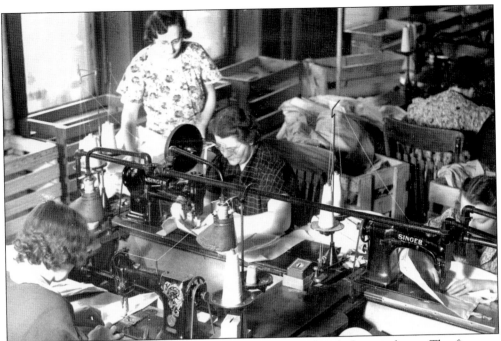

The oldest Polish manufacturing industry in Chicago is the clothing industry. The first one was founded in the 1860s on Lake Street by D. Wilkowski. In Polish Downtown there were several garment factories. These women are sewing at the Kabo Corset Company at 1065 North Milwaukee Avenue in 1939.

There were a great number of Polish photographers operating in the neighborhood. One of those was the Washington Photo Art Studio, established in 1913 at 879 North Milwaukee Avenue by Wladyslaw M. Rozanski. Mr. Rozanski won a silver medal for his artistic photography at the General National Exhibition in Poland in 1929. This is his ad from a 1922 Holy Trinity Jubilee book.

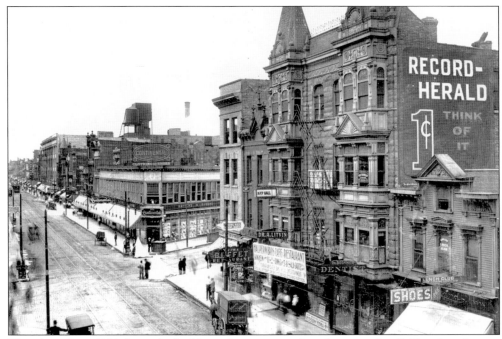

This photo from 1911 shows the buildings that once stood on the east side of Milwaukee Avenue at the intersection of Ashland Avenue. They were demolished in the 1920s when Ashland was widened. Poles began moving into stores and offices on Milwaukee in the 1910s and by the 1920s predominated along this commercial street, which has long been synonymous with the Polish American community in Chicago. (Courtesy of Chicago Historical Society, ICHi-04579.)

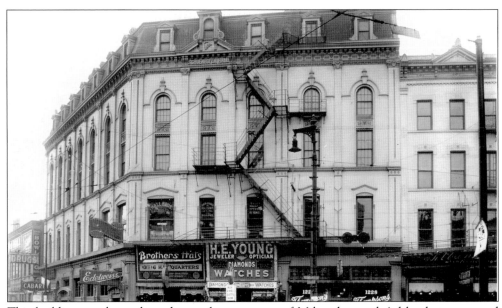

This building was located on the southwest corner of Milwaukee and Ashland avenues and was replaced in 1930 by a shorter storefront structure when Ashland Avenue was widened. (Courtesy of Chicago Historical Society, ICHi-24131.)

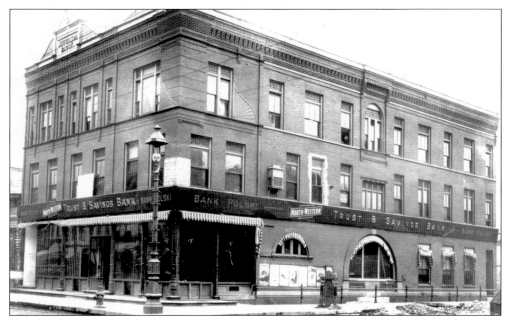

The first location for Northwestern Trust and Savings Bank was at 1152 North Milwaukee Avenue. This was the first Polish-owned bank in Chicago, commonly known as *Bank Polski*, and was founded in 1906 by John Smulski with John F. Przybysz. This building is still standing and is the home of Planned Parenthood. (Courtesy of Chicago Historical Society, ICHi-20950.)

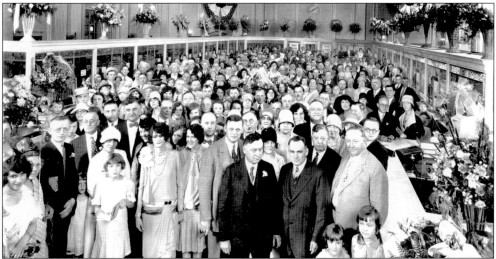

John Smulski was a civic leader who served as an alderman, city attorney, president of the West Park Commission, and state treasurer. He left his practice as an attorney in 1906 to found *Bank Polski*. During the first World War he made many trips to Poland to aid in its liberation. For his War Relief efforts with Paderewski at the Polish Central Relief Committee and Polish American National Department he won the French Legion of Honor award and Poland's Order of Polonia Restituta. His suicide in 1928 was a shock to Polonia. Newspapers of the time reported that he took a revolver to his head to stop his painful suffering from cancer. Smulski is pictured in a dark suit in front on the left at the opening of the Second Northwestern State Bank on July 9, 1927.

The Northwestern Trust and Savings Bank moved to 1201 North Milwaukee Avenue in 1920 when that building was constructed. It had over $22 million in deposits in 1927 and was a very successful bank. In this photo from the 1920s, the bank has been designated as a station for people to pay their taxes. After the bank closed, this building became the location of Alliance Printers and Publishers in 1942. This building is still standing and is the home of City Sports.

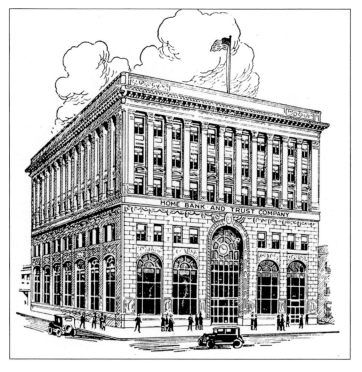

Another prominent bank in Polish Downtown was the Home Bank and Trust Company. This is a 1927 rendering of the building designed by Karl M. Vitzhum and built for them in 1925. In 1939, Manufacturers National Bank Building moved into this building, which they then purchased in 1945. Manufacturers Bank had been first founded in 1934 as Milwaukee Avenue National Bank of Chicago and operated for a few years in the former Northwestern Trust and Savings Bank Building. Mb Financial Bank is now operating at this location.

Seven

ARTS, CULTURE, AND RECREATION

A strong literary and dramatic tradition runs deep in the hearts and minds of Poles. Polish writers and poets are revered for expressing in words the sufferings and longings of the Polish soul, particularly during their darkest century of foreign rule. The novels of Henryk Sienkiewicz, the dramas of Julius Slowacki, and the comedies of Alexander Fredro were adapted and performed by amateur parish literary and dramatic circles to audiences of thousands in the parish halls of Polish Downtown. The poets Adam Mickiewicz and Zygmunt Krasinski were published by the Polish press and read aloud in parish literary circles.

St. Stanislaus Dramatic Circle was the oldest Polish dramatic society, organized in 1891. In their early years, they performed in a 5,000-seat auditorium, the largest in Chicago at the time, with a fully equipped stage and a balcony on three sides. When this was destroyed by a fire in 1907, a smaller auditorium was built with a capacity of 1,200. Not surprisingly, the second oldest Dramatic Circle was at Holy Trinity, organized in 1895. The auditorium in its 1929 high school building became the largest in Polish Downtown, with a capacity of 1,500.

Dramatic work in the parish circles was at its peak in the 1910s. Many world-renowned Polish performers who came to Chicago did courtesy performances at either St. Stanislaus or Holy Trinity. Among them were Ignace Paderewski (1860–1941), the Polish pianist and statesman, Jan Kiepura (1902–1966), a tenor with the New York Metropolitan Opera, and Helen Modrzejeska (1840–1909), a nationally acclaimed Shakespearean actress. The 1910s were also a high point for professional Polish theater. The first company appeared in 1910, and during World War I there were eight active professional Polish theaters in Chicago. After the war, motion pictures began to compete and live theater declined dramatically, with all live commercial Polish theaters closed by 1929.

Music played a prominent part in Polish life and again the Catholic parish was at the center. The Poles who immigrated to Chicago's Polish Downtown carried with them a longing for the culture of their homeland. To express this longing they started choirs and choral societies in every parish they founded. The first parish organist was Peter Kiolbassa at St. Stanislaus, who came from Panna Marya in Texas, the first Polish parish in America. He gave up music for politics, becoming the first Pole elected to office in Illinois as a member of the Illinois State legislature in 1877 and then Chicago city treasurer. Andrew Kwasigroch became organist of St. Stanislaus in 1875. With so many individual choirs, a national choral organization, the Polish Singers Alliance of America, was founded in Chicago at Holy Trinity to propagate this love of Polish music and song throughout the United States.

Visual arts in the Polish community were expressed primarily in religious art created in churches, or for patriotic purposes. Although art was not as prevalent as literature, drama, and music, an early organization, the Polish Arts Club, was founded with one of its purposes to

foster exhibits of Polish artists.

Sports of all kinds were also organized through the parish system. St Stanislaus opened the first gymnasium, the White Eagle Turners Hall, as an athletic facility and social center for young men in the parish. Many people were shocked at the expense incurred by a religious institution for this type of facility. However, it proved to be an excellent idea. Humboldt Park, part of the city's regional park system, was used by Polonia for many of its largest events. Closer to home, Pulaski Park was the major recreational facility in the neighborhood. Initiated by outside social reformers in 1911, it displaced many buildings and residents, but became an important asset for the community. (Photographs in this chapter from the archives of The Polish Museum of America except as noted.)

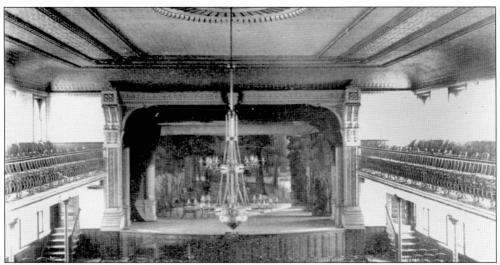

The first dramatic productions in Polish Downtown were staged in the large auditoriums at St. Stanislaus and Holy Trinity parishes. Performances at Holy Trinity were held in this old school hall, which only had a capacity of 900. It was destroyed by fire in 1904 when an amateur player forgot to blow out burning candles under the stage after a rehearsal.

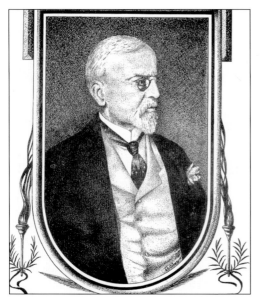

Henry Sienkiewicz (1846–1916) is considered Poland's greatest novelist. His novel of Roman times, *Quo Vadis*, gained him international recognition. Written in 1896, it has been translated into countless languages. His works of historical fiction were often serialized in the pages of the Polish press and his first visit to Chicago was in the late 1870s. Sienkiewicz received the Nobel Prize for Literature in 1905.

The oldest dramatic circle in Polish Downtown was founded at St. Stanislaus in 1891. It regularly produced classical drama by Polish authors such as Sienkiewicz, Slowacki, and Fredro on a large scale and of high artistic merit. The director of the St. Stanislaus Circle was Szczesny Zahajkiewicz, who not only adapted these great literary works for the theater, but also wrote 60 original plays and translated others for amateur parish needs. This is the cast for a performance of *Quo Vadis*.

In the 1910s, just as theaters and movie palaces were being built across the country, so too were theaters being built in this neighborhood. During World War I, there were eight active Polish theaters in Chicago, often showing a moving picture in the early evening, followed by a full-length drama. This is an ad for the Paulina Theater, built in 1913 at 1339 North Paulina Street and closed in the 1950s (now the site of the Jewel parking lot). Its 16-rank Wurlitzer organ was rebuilt and is in use at the Copernicus Polish Cultural Center at 5216 West Lawrence Avenue.

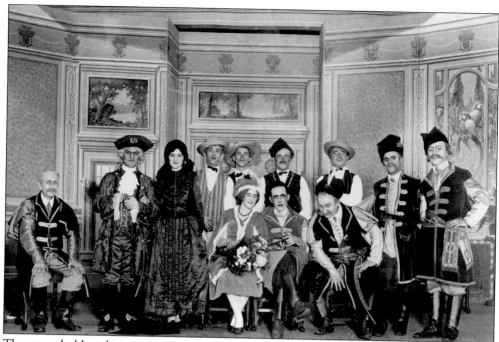

The second oldest dramatic circle, not surprisingly, was organized at Holy Trinity in 1895. It sponsored public lectures and offered evening courses in music, song, literature, and language. In 1902, a Literary Circle at Holy Trinity was organized by Rev. Sztucczko. This is a production of the comedy *Zemsty* (*Revenge*) by Fredro, considered by many to be the "Polish Moliere." It was held in the Holy Trinity auditorium on November 3, 1929, and its staging and costumes were faithful to the 18th century when the play was written.

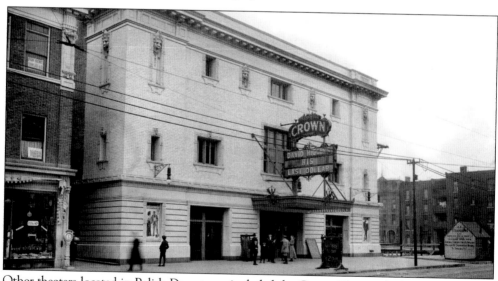

Other theaters located in Polish Downtown included the Crown Theater, built in 1909 at 1605 West Division Street (now the site of Wendy's), and the Chopin Theater, built in 1918 at 1541 West Division Street, and the only Polish theater still standing in the neighborhood. This is the Crown Theater shortly after it opened in 1909. The Division Street YMCA was later built to the right (west) of the theater. (Courtesy of Chicago Historical Society, DN-0007995.)

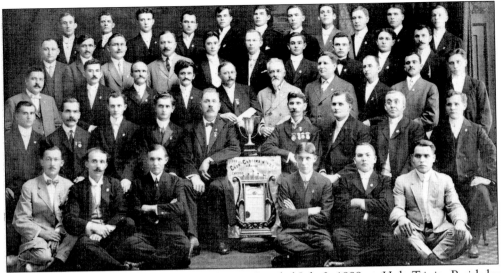

The Chopin Choir, an all-male ensemble, was founded July 3, 1888, at Holy Trinity Parish by Anthony Mallek. This is Chopin Choir #1 at its 25th Jubilee, held at Wicker Park Hall on September 28, 1913.

(*left*) Also from Holy Trinity, Agnes Nering was considered Polonia's greatest singer. Born in 1876 in Chicago and educated at Holy Trinity parish, Holy Family Academy, and Chicago Musical College, she became a noted concert coloratura soprano and a brilliant teacher. She gave music lessons in her home at her School of Vocal Art and Dancing. Mrs. Nering died an untimely death in 1922 at age 46. This photo is dated June 28, 1912.

(*right*) Perhaps the most outstanding of the pioneer church organists was Anthony Mallek, who served at Holy Trinity as organist and teacher for 26 years from 1880 to 1916. Mallek was the founder and conductor of its parish choir. With the founding of the Polish Singers Alliance in 1888, he became its president and first general choral director. Born in Poland in 1851, Mallek came to Chicago in 1880. He was also a composer who published a monthly paper on Polish music called *Ziarno* and 17 Polish songbooks.

The Music and Literary Society Leo XIII was founded at St. Stanislaus parish in 1897. These are officers of the first society. Parish and independent amateur groups were organized on March 20, 1927, under the Alliance of the Polish Literary Dramatic Circles of America.

On May 13, 1889, the Chopin Choir met and organized the Polish Singers Alliance of America. In the first 50 years of its existence, 243 choirs applied for membership. It quickly became a national organization, with 10 circuits, each representing a cluster of states. Each circuit held an annual contest and concert while the whole organization held a national contest, concert, and conference every three years. This is the logo of the organization.

The Kosciuszko Monument is more than a work of sculpture. It has become a symbol of all the nationalistic aspirations of Chicago's Poles. Kosciusko was a Polish and American war hero, having fought in the American Revolution. The monument was donated by the Polish National Alliance and unveiled in Humboldt Park on September 11, 1904, with 100,000 Poles attending the ceremony. It was designed by Kazimierz Chodzinski (1861-1919), a Polish sculptor from Krakow who lived in the United States for a few years between 1903 and 1910. Chodzinski also completed the Pulaski Monument in Washington D.C. The Kosciuszko Monument was relocated to Solidarity Drive near the Planetarium in 1978. (Collection of the author.)

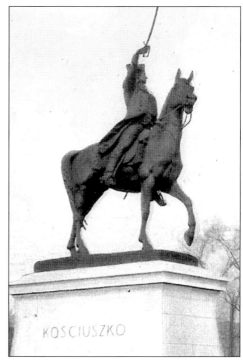

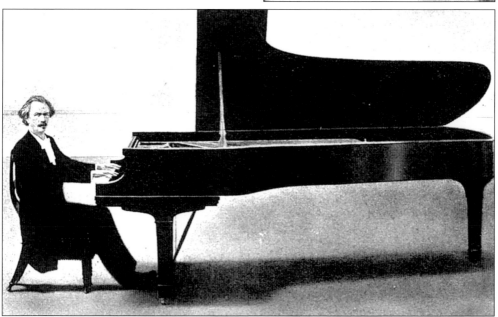

The great Polish pianist, Ignace Jan Paderewski, made his first American tour and Chicago performance in 1891, followed by several memorable performances in Chicago. His final Chicago concert was at the Civic Opera House in 1932. The three-hour concert was followed by two hours of encores, with the audience standing the whole time. This postcard shows Paderewski at the last piano he played in concert. It was recently restored by the Steinway Company and is on display in the Paderewski Room at the Polish Museum, along with artifacts commemorating this Polish pianist, president, and statesman.

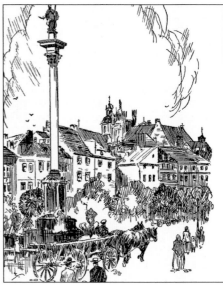

(*left*) Stanislaus Szukalski was a Polish-born sculptor and painter who studied at the Academy of Arts in Krakow. He is seen here in his Chicago studio in 1914 with one of his works. Some of his sculptures and paintings are on display at the Polish Museum. All his works in Poland were destroyed during the bombing of Warsaw by the Nazis in World War II. (Courtesy of Chicago Historical Society DN-0063787.)

(*right*) Harriet and Walter Krawiec were a husband/wife team of Chicago painters. Walter illustrated the book, *The First Cardinal of the West*, by Paul R. Martin, which originally appeared in serial form in the *New World* Chicago Archdiocesan newspaper in 1934. This illustration was intended to show the great respect Cardinal George Mundelein had for Chicago Poles. The caption in the book reads: "He knew the Poles, knew their loyalty to Holy Mother Church, knew with what fidelity they had kept the Faith under schismatic domination." Walter Krawiec was the staff artist for the newspaper *Dziennik Chicagoski*. (Collection of the author.)

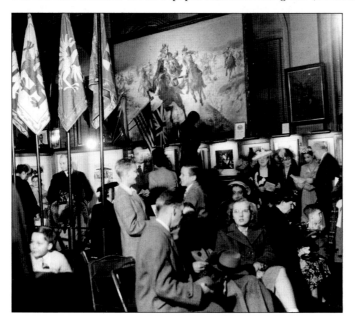

The Polish Arts Club was founded on February 14, 1926, by Thaddeus Slesinski. Its original purpose was to give appreciation, encouragement, and support to young Polish artists in the fields of art, music, literature, and dramatics. Its first exhibit was held at 1200 North Ashland Avenue. This is one of their meetings at an art exhibit at the Polish Museum in 1945. The organization still operates today, sponsoring art exhibits, lectures, and concerts at various locations throughout Chicago.

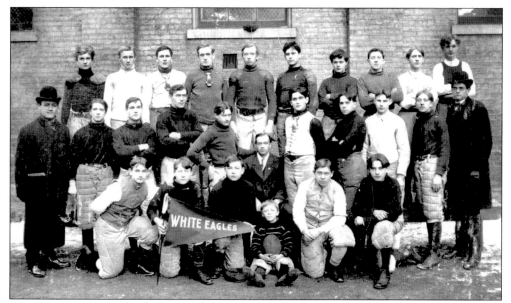

The White Eagles were the first Polish football team, organized by the Polish Falcons from members of St. Stanislaus Parish. The captain and quarterback was August M. Kowalski, seen in the front row holding the Eagles part of the team banner in this photo from 1899. The team was undefeated in 1900, 1901, 1902, and 1903.

St. Stanislaus also sponsored a White Eagles softball team. This is the 1905 team. They played at the baseball diamond at Blackhawk and Elston, which was referred to as "Polonia Park."

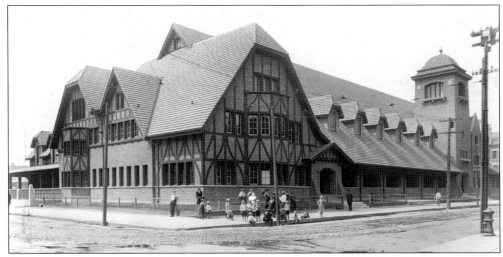

Pulaski Park was built from 1912-1914 during the Progressive Reform Movement by the West Park Commission. By the 1900s, social reformers were advocating that mid-sized parks be inserted into dense urban neighborhoods to serve the poor, immigrant working classes. The fieldhouse at Pulaski Park was designed by William Carbys Zimmerman and the park plan and landscape design were by Jens Jensen. Zimmerman was the architect for the West Park Commission beginning in 1907, and Jensen was the chief landscape architect and general superintendent from 1905-1920. This is the main façade of the fieldhouse facing Blackhawk Street. (Courtesy of Chicago Park District Archives.)

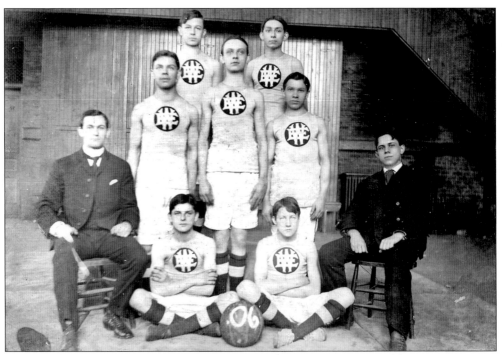

This is the St. Stanislaus White Eagles basketball team of 1906. They played in the gymnasium built by Rev. John Kasprzycki for St. Stanislaus parish. Many of the same players were on each of the sports teams.

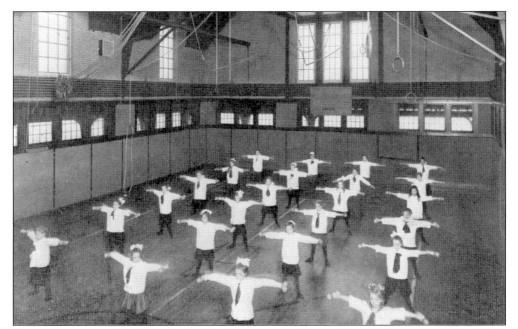

The architecture of the Pulaski Park fieldhouse resembles an Eastern European meeting hall, and contains men's and women's gyms, an auditorium, and various club rooms. A branch of the Chicago Public Library was once here and English classes were offered. This is a girls' gymnasium class from the late 1910s. (Courtesy of Chicago Park District Archives.)

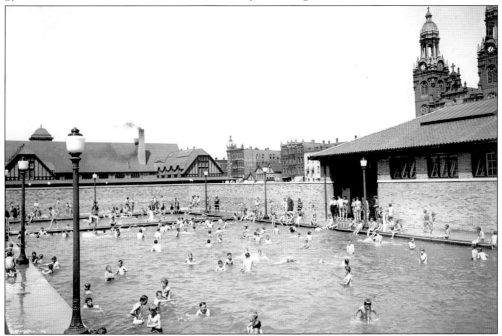

Pulaski Park is 3.8 acres. The poolhouse is located on the park's southern edge, flanked by the swimming pool and the playground to the west. The poolhouse roof is visible to the right, with St. Stanislaus' twin towers seen in the distance behind it. These children were photographed in 1917. (Courtesy of Chicago Park District Archives.)

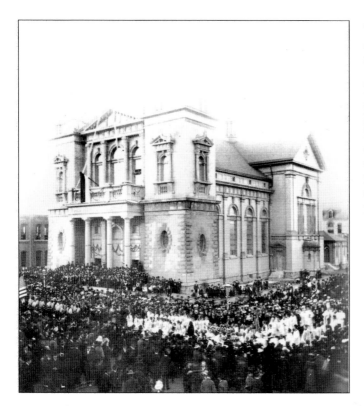

Thousands attended the dedication of St. Hedwig's Church on October 26, 1901. The cornerstone had been laid just two years earlier, with Mayor Carter Harrison, Archbishop Feehan, the Polish cavalry, and the marching members of hundreds of neighboring parish societies—36 parish societies from St. Stanislaus parish alone.

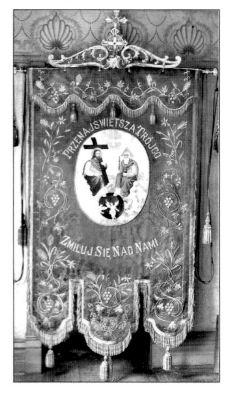

Every parish, club, association, team, or organization needed their own banner to identify them at parades and large events. Two Polonia firms were active in designing and sewing banners. This one was created by the W. Slominska Banner and Badge Company for Holy Trinity church. The center image shows the three persons in the Trinity: God the father, Jesus Christ, and the Holy Spirit. The Polish inscription is translated as "Most Holy Trinity, Have Mercy on Us."

Eight

PROCESSIONS, PARADES, EVENTS, AND CELEBRATIONS

For Chicago's Poles, almost anything was a reason for a procession, a parade, an event, or a celebration. There were religious processions and devotions, political parades and demonstrations, and the meetings and conventions of the many fraternal associations. Then there were events that simply celebrated some aspect of Polish culture.

Each time a Catholic parish reached some milestone in the construction of a new parish building, it was the occasion for a procession through the neighboring streets and a mass inside the church. That could include groundbreakings, cornerstones, dedications, or jubilees. Every parish society would march with banners held aloft, musicians would play, clerics would file by in white robes, and parishioners would crowd around the processional route. In front of the site or structure there would be a solemn blessing, often by the city's Catholic Archbishop. Newspaper clippings of the day reported the Polish cavalry on horseback at some parish groundbreakings. Communions, confirmations, graduations, and funerals also often involved an outdoor procession. For example, graduations at St. Stanislaus College on Division Street involved a solemn procession around the corner and up Noble Street to St. Stanislaus parish hall.

For political or nationalistic commemorations, there were parades with floats depicting early Polish history, marching bands, political dignitaries, and representatives from every major Polish association, club, team, or parish. The largest of these was and still is held in honor of Polish Constitution Day, the May 3rd Polish National Holiday. The first Polish Constitution Day parade was initiated by the Polish National Alliance in 1891. The parade route was a long thread that connected the life of Chicago Poles. Beginning at Holy Trinity Church, it ended in the shadows of the statue of Polish American patriot Thaddeus Kosciuszko in Humboldt Park. Marching units organized on the side streets of Polish Downtown and stepped off at the Polish Triangle of Division, Ashland, and Milwaukee avenues. Not just Constitution Day, but any event associated with the cause to free Poland was reason for a parade. One of the largest was held in downtown Chicago in 1938 on the 20th anniversary of the establishment of a free Polish nation.

The large fraternal associations clustered in Polish Downtown each held *Sejmy*, or conventions. At first these *Sejmy* were held annually, then biannually, and then quarterly, frequently in Chicago, where the headquarters were all located. There would be meetings, banquets, and usually a mass at either St. Stanislaus or Holy Trinity, depending on the affiliation of that particular fraternal. At these occasions delegates often posed in large groups in front of one of the institutional buildings of Polish Downtown. The people on the cover of this book are attendees at the 44th *Sejm* of the Polish Roman Catholic Union and are posed on the front steps of St. Stanislaus Kostka church.

Other annual events celebrated Polish culture with musical programs, historic presentations, speeches, and various activities. One of these is Polish Day, first initiated at the 1893 World's Columbian Exposition held in Jackson Park, and then begun again after World War I as an annual demonstration of civic consciousness and a way of raising money for educational and charitable causes. Chicago's early Polish immigrants lived within a dense, tight-knit community, and public events and celebrations were simply the natural expression of the collective community life of Polonia. (All photographs in this chapter are from the archives of The Polish Museum of America.)

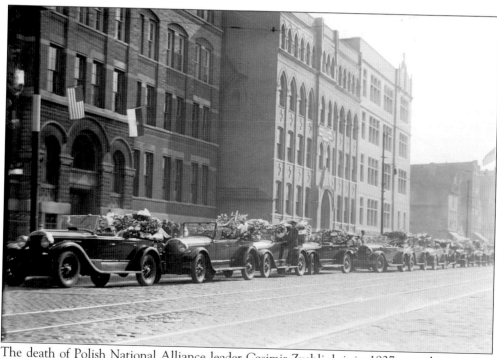

The death of Polish National Alliance leader Casimir Zychlinksi, in 1927, was the occasion for a long funeral procession down Division Street. Zychlinski was born in Poland in 1859 and came to the United States in 1876. He served as President of the Polish National Alliance from 1912 until his death in 1927. Due to his efforts the organization grew from 110,000 members with assets of $3 million in 1915 to 250,000 members and assets of over $14 million in 1926.

For his contributions to Polish immigrants, the Polish government awarded Zychlinski the Commander's Cross of the Order of Polonia Restituta. He was also one of the founders of the Polish Falcons Alliance of America in 1894 and is known as the Father of the Falcons. This is his funeral parade coming south on Milwaukee Avenue, and turning the corner north up Noble Street.

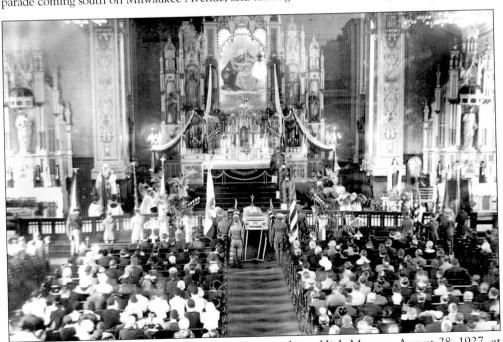

The funeral parade for Zychlinski culminated in a solemn High Mass on August 28, 1927, at Holy Trinity Church, the religious center of the Polish National Alliance. The main altar is seen here decked out in bunting, and flags flanked the casket.

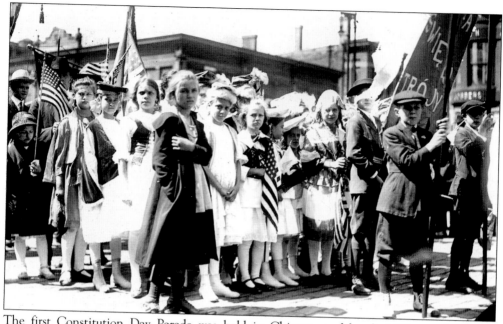

The first Constitution Day Parade was held in Chicago on May 2, 1891, on the 100th anniversary of the Polish constitution. There was a musical program and speeches held at the Central Music Hall in downtown Chicago. These children are gathering for the 1920 Constitution Day parade, which traveled through the streets of Polish Downtown. The banner on the right identifies them as being from Holy Trinity School.

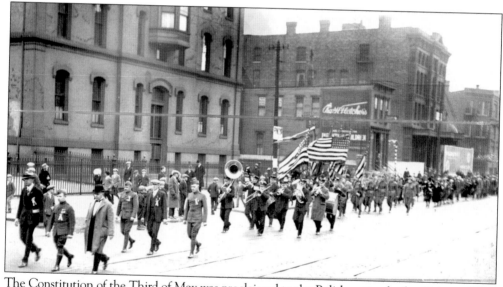

The Constitution of the Third of May was proclaimed to the Polish nation by free Poles in 1791. It established religious tolerance and made every citizen equal before the law under a limited monarchy. Yet within just one year, Polish lands began to be divided up between the neighboring foreign powers of Russia, Prussia, and Austria. The second partition in 1793 stirred up patriotism under General Thaddeus Kosciuszko, who was taken prisoner by the Russians in 1794. By 1795, with the last partition, Poland ceased to exist as an independent nation. This band is marching past the old Holy Trinity High School on Division Street, probably in the early 1920s.

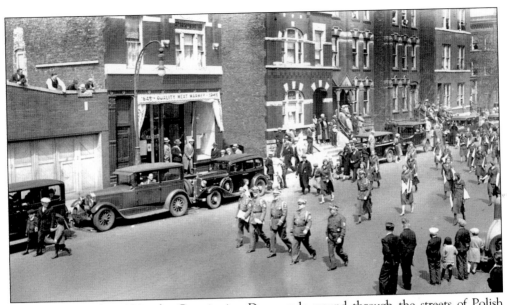

For years, until the 1970s, the Constitution Day parade wound through the streets of Polish Downtown, typically starting at Holy Trinity Church, moving west on Division Street, south on Ashland Avenue to Augusta, and then west on Augusta approximately two miles to Humboldt Park, concluding under the statue of Thaddeus Koscisuzko. These marchers are moving west on Augusta Boulevard. The 200th anniversary of the Polish constitution was observed on May 3, 1991, with a mass at Holy Trinity and a parade on Dearborn Street in downtown Chicago.

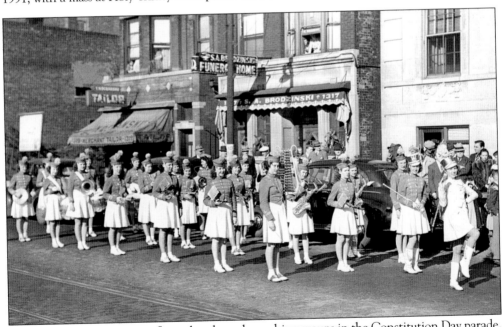

Because there were so many floats, bands, and marching groups in the Constitution Day parade, they organized in various places throughout the neighborhood. The kickoff spot was usually at the corner of Division, Ashland, and Milwaukee. This girls' marching band is gathered in the 1300 block of Ashland Avenue for a 1945 parade. The Polish Women's Alliance building is visible behind them on the right.

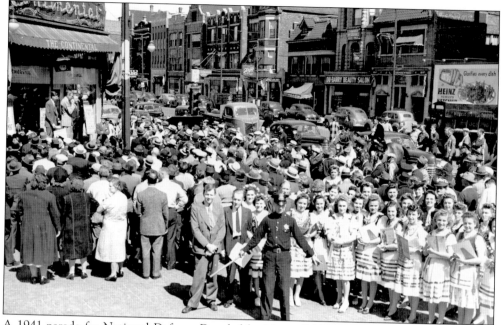

A 1941 parade for National Defense Day, led by Mayor Ed Kelly, organizes at the northwest corner of Milwaukee and Ashland avenues.

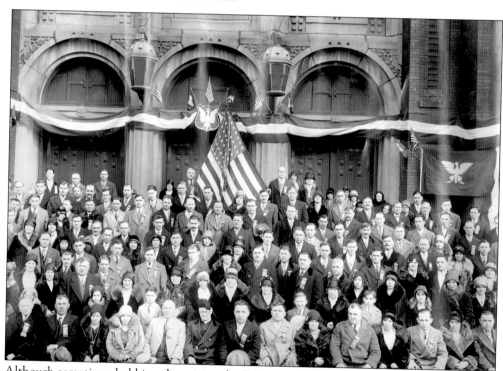

Although sometimes held in other cities, the *Sejm* or convention of most major fraternals was usually held in Chicago, in the local churches and headquarters offices of Polish Downtown. This group is the Sacred Heart Society #471 of the Polish Roman Catholic Union of America at Holy Innocents Church at the corner of West Superior and North Armour streets in 1929.

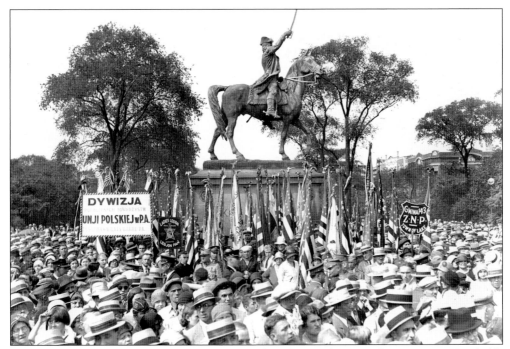

Members of the Polish National Alliance are gathered around Kosciuszko's statue in Humboldt Park for a demonstration. The banner with the abbreviation ZNP indicates the name of the organization in Polish, *Zwiazek Narodowy Polski*.

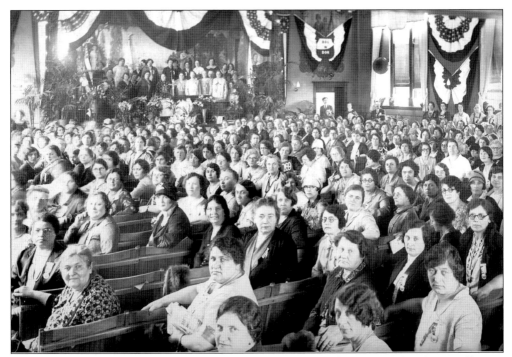

This *Sejm* for the Polish Women's Alliance was held in the auditorium of their home offices at 1309 North Ashland Avenue from August 21-27, 1927.

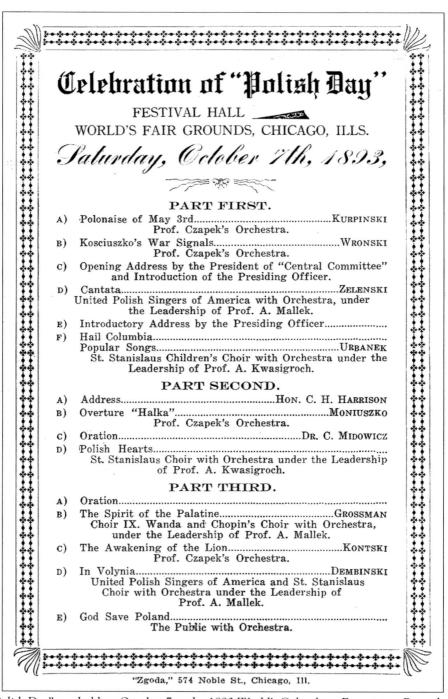

Celebration of "Polish Day"

FESTIVAL HALL
WORLD'S FAIR GROUNDS, CHICAGO, ILLS.

Saturday, October 7th, 1893,

PART FIRST.

A) Polonaise of May 3rd....................................KURPINSKI
 Prof. Czapek's Orchestra.

B) Kosciuszko's War Signals..............................WRONSKI
 Prof. Czapek's Orchestra.

C) Opening Address by the President of "Central Committee"
 and Introduction of the Presiding Officer.

D) Cantata..ZELENSKI
 United Polish Singers of America with Orchestra, under
 the Leadership of Prof. A. Mallek.

E) Introductory Address by the Presiding Officer......................

F) Hail Columbia.
 Popular Songs...URBANEK
 St. Stanislaus Children's Choir with Orchestra under the
 Leadership of Prof. A. Kwasigroch.

PART SECOND.

A) Address..............................HON. C. H. HARRISON

B) Overture "Halka".................................MONIUSZKO
 Prof. Czapek's Orchestra.

C) Oration..DR. C. MIDOWICZ

D) Polish Hearts...
 St. Stanislaus Choir with Orchestra under the Leadership
 of Prof. A. Kwasigroch.

PART THIRD.

A) Oration..

B) The Spirit of the Palatine.........................GROSSMAN
 Choir IX. Wanda and Chopin's Choir with Orchestra,
 under the Leadership of Prof. A. Mallek.

C) The Awakening of the Lion........................KONTSKI
 Prof. Czapek's Orchestra.

D) In Volynia...DEMBINSKI
 United Polish Singers of America and St. Stanislaus
 Choir with Orchestra under the Leadership of
 Prof. A. Mallek.

E) God Save Poland.....................................
 The Public with Orchestra.

"Zgoda," 574 Noble St., Chicago, Ill.

A "Polish Day" was held on October 7 at the 1893 World's Columbian Exposition. Regarded by Chicago Poles as a demonstration of Polish strength in this city, it featured an orchestral and choral program performed by local Polish musical organizations, including Professor Czapek's Orchestra, the United Polish Singers of America under Holy Trinity organist Anthony Mallek, and the St. Stanislaus Choir and Children's Choir under St. Stanislaus organist Andrew Kwasigroch. Over 100,000 people were estimated to have attended.

The Polish Day Association, which included the largest Polish organizations, was formed in 1926 to host Polish Day Festivals. Not just about cultural pride, the purpose of these festivals was also to raise money for charitable purposes to benefit people of Polish descent. These festivals were frequently held in Riverview Amusement Park, on the eastern banks of the Chicago River on the city's northwest side. This photo is Polish Day, sometime in 1918. The banners say "Paderewski" and "God Save Poland" (*Boze Zbaw Polske*). Helena Paderewska, wife of the visiting Polish patriot, is the third person from the left.

At the 1933 Chicago Century of Progress World's Fair, the Polish Day Association sponsored an entire Polish Week of Hospitality from July 17-23, 1933. Events were held all over the city, with concerts and banquets at downtown halls and hotels, with masses and celebrations at local Polish parishes, and with tours of schools, newspapers, and fraternal home-offices. July 22 was set as the official Polish Day on the grounds of the fair. The day began with a parade culminating at Soldier Field. There a pageant and spectacle were performed, with 50 floats, a chorus of 1,000, and 300 dancers.

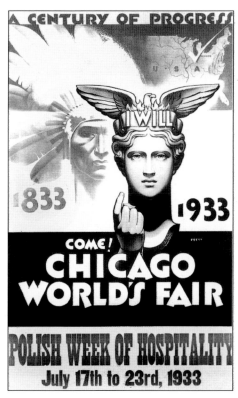

FREE POLAND

A SEMI-MONTHLY

The Truth About Poland and Her People

Vol. I—No. 2 579 **OCTOBER 1, 1914** 5 Cents a Copy

Published by the Polish National Council of America

Free Poland was written in English to build friendship between America and Poland. Its articles illustrated the rich intellectual and cultural legacy of Poland and presented reasons why Poles were demanding political independence. It was attempting to build an attitude in America so that the United States would do everything possible to ensure the rights of a free Polish nation. The first issue came out on September 1, 1914, published by the Polish National Council of America at 984 North Milwaukee Avenue. Any contributions toward their efforts were to be sent to Northwestern Trust and Savings Bank.

Nine

A FREE POLISH NATION

The desire to free Poland lay in the minds and hearts of probably every Pole from the day he or she stepped foot in America. Ever since the final partition of Polish lands between Russia, Prussia, and Austria in 1795, Poles longed to escape their foreign oppressors and reestablish an independent Polish nation. Many Poles celebrated when World War I broke out, believing it presented their greatest opportunity. And so it became the "War for Poland." The War for Poland offered a reason for the battling factions within American Polonia to put aside their ideological differences and work together. The Polish Roman Catholic Union, Polish National Alliance, Polish Women's Alliance, Falcons, Alliance of Polish Clergy, and the Polish National Council organized a Polish Central Committee in America in October 1914 as a way to collectively raise money and recruit an army.

Within two years, a Polish National Department was organized by Ignace Paderewski, John Smulski, and Bishop Paul Rhode as an umbrella organization to coordinate all Polish war activities. Chicago banker and civic leader John Smulski was appointed its president. U.S. President Woodrow Wilson recognized Paderewski as the official representative of Poland's "Fourth Part," that is, those Poles living in America. A special agreement between Wilson and the French government permitted American Poles to join the Polish Army, which fought fiercely under Gen. Josef Haller to liberate Poland. Chicago's Polonia became unwavering supporters of President Wilson, lauding his demands for a "free and independent Poland, with access to the sea" as his 13th condition of peace. Interestingly, it was this support that led Poles in this country to become more American, as citizenship and voter registration drives were spearheaded by the fraternals to ensure Wilson's reelection.

One of the greatest war efforts of American Polonia was its massive fund-raising success on behalf of Poland, organized and run out of Chicago's Polish Downtown. The Polish press exhorted people to contribute, while the parishes and fraternals collected money and sent it off to Poles in war-torn Europe. Poles raised some $50 million for war relief programs, including $5 million for the Polish National Fund, $1.5 million for the Polish Army, and $3 million in food and clothing. Despite being a poor, working-class community, Polonia also bought nearly $100 million in US Liberty Bonds.

On November 11, 1918, the independence of Poland was proclaimed. Marshal Joseph Pilsudski was named chief of state and Ignace Paderewski, prime minister. However, the new nation was a shambles and its people were hungry and homeless. Under Herbert Hoover a food mission was begun in 1919 to deliver food to the Polish government, who would distribute it to its citizens. Within months, 14,000 tons of food (three shiploads) reached the seaport of Gdansk and many more tons followed.

The new nation of Poland had barely 20 years to rebuild, when once again it was torn apart by

war. In 1939, Hitler's and Russia's armies began crisscrossing Poland, displacing Polish citizens and destroying communities: 1.5 million Polish citizens were deported to Russia, Siberia, and Kazakstan by the Soviet government when the Soviet army invaded Eastern Poland in September 1939. America's Polonia sprang into action again. Food, clothing, and medicine were sent for some three million displaced Poles, most of whom were homeless wanderers for over three years. Financial support was provided for refugee camps for Polish orphans in India, Iran, and East Africa. Newspapers were secretly printed to instigate the Polish people into stubborn resistance to the German occupation. When World War II ended, Poland was once again under the control of a foreign power, this time Soviet communism. It would not be until 1989 that Poland regained the freedom to govern its own nation. (Photographs in this chapter are from the archives of The Polish Museum of America.)

Polish American women participated in the war effort in large numbers, being involved in fund-raising, relief packages, and various support activities for the troops fighting in Europe. This flag was presented to the Polish Army in France by the Polish Women's Alliance on October 14, 1917. It translates as "A Free, United, Independent Poland!"

The Military Commission recruiting for the Polish Army in France was created September 20, 1917, by the Polish National Department in Chicago. The first 12 recruiting centers were to open on October 4 in major cities in the eastern and midwestern United States. Within weeks an additional 28 centers opened in scattered smaller cities with a training camp established in Niagara Falls, Ontario, Canada. This photo is in front of the recruitment center at the Polish Roman Catholic Union.

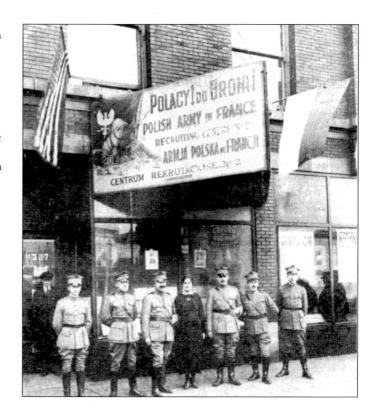

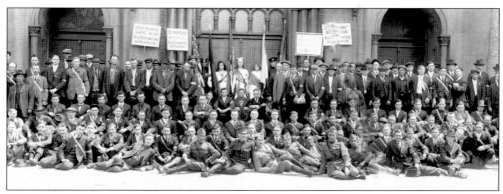

Polish Catholic parishes were encouraged by Bishop Paul Rhode, Chicago's first Polish bishop, to help recruit for the Polish Army in France. The Polish press in Chicago was also influential, through its combined circulation of over 300,000 by the end of World War I. About 25,000 American Poles, including 3,000 volunteers from Chicago, served in the Polish Army. At the same time, among the Poles living in occupied Polish lands in Europe, 600,000 were conscripted into the German army, 600,000 into the Austrian army, and 1.5 million into the Russian army. Thus ethnic Poles fought against fellow ethnic Poles under different flags. These Polish American soldiers are gathered on the steps of St. Josephat Church on Southport Avenue. The signs urge them to "Be Polish" and sign up for the Polish army at the Polish Roman Catholic Union.

John Smulski (1867–1928), a leader of the Polish National Alliance, headed up the Polish National Department of America, a political action federation that worked with Ignace Paderewski, spokesman in the United States for the Polish National Committee in France, and Henryk Sienkiewicz. In this photo, Smulski is on the left and Paderewski on the right. Paderewski devoted himself to the cause of Polish nationalism from 1910 to 1920 and served as Prime Minister of the newly created nation and delegate to the League of Nations. (Courtesy of Chicago Historical Society DN-0074497.)

Publisher, banker, and civic leader John Smulski bought this Wicker Park home at 2138 West Pierce in 1902 as the wealthy Germans who built the homes were moving out of the neighborhood. It served as the Polish Consulate for a time and became renowned when Paderewski played the piano to a crowd from the front porch on his trip to Chicago in 1932. Polish writer and French army officer Waclaw Gasiorowski is seated in the center of this group wearing a sash.

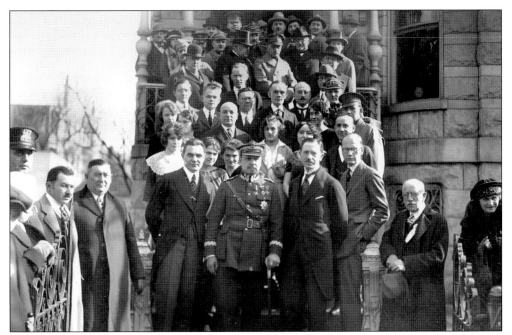

Gen. Josef Haller, a former Austrian officer, led the Polish Army in Europe, sometimes called the "Blue Army" because of the colors of its French uniforms. Haller is being honored by the Polish Consul General on the steps of the Polish Consulate at 1115 North Damen on November 8, 1923.

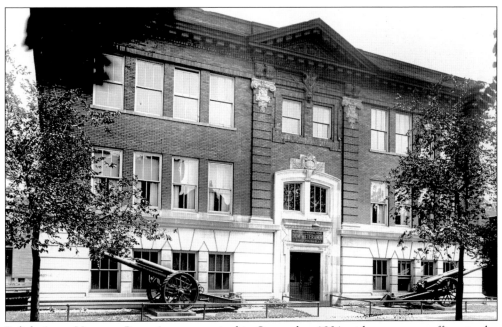

Polish Army Veterans Post #1 was organized in September 1921 with temporary offices in the Polish Women's Alliance building at 1309 North Ashland. They were in several other locations until finally settling in this former Jewish women's building at 1239 North Wood Street. The first president of the post was Dr. Aleksander Pietrzykowski.

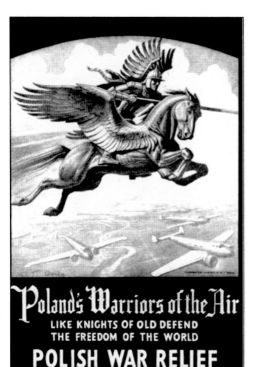

This poster for Polish War Relief during World War II was created by Polish-born painter, sculptor, and illustrator, Wladyslaw T. Benda. Benda immigrated to the United States in 1890 and lived in New York City. He was decorated with the Order of Polonia Restituta by the Polish government. The Warriors of the Air it refers to are Polish Flight Squadron 303, trained Polish fighter pilots who joined with Britain's Royal Air Force and fought alongside them in the Battle of Britain. (Original art on display at The Polish Museum of America.)

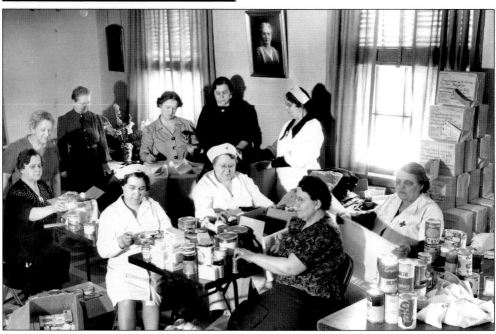

During World War II, there were 430,000 Polish prisoners of war in Germany and 11,000 in Switzerland. Workshops such as this one at the Polish Women's Alliance on April 20, 1941, were held to package goods for war prisoners in Poland. Financial support for the establishment of a high school and three university centers for Polish soldiers interned in Switzerland was provided by the Polish American Council.

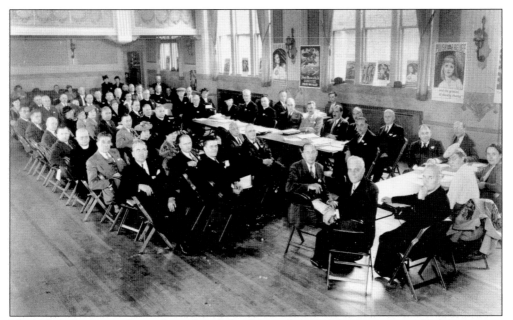

The Polish American Council was founded in November 1939 by Americans of Polish ancestry to help Polish victims of war. By 1942 they began to seek outside help from the American public at large. It was recognized as the central agency for Polish War Relief in the United States by the U.S. Department of State. Its offices were at 1200 North Ashland. This is a meeting organized for war relief efforts in 1944.

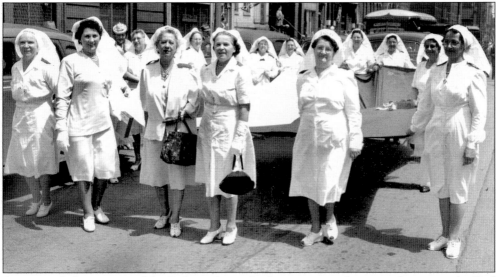

American Poles were cited by Paderewski as the largest nationality contributing to the Red Cross campaign in the United States during World War I. One Polish bank in Chicago received over 13,000 Polish subscriptions exceeding $1.5 million. The first Red Cross arrived in Poland in March of 1919 and was dedicated to medical relief and relief for children. Polish American women continued collecting for war relief through World War II. These women are marching in the Polish Constitution Day parade in 1947 carrying a large Polish flag into which spectators were encouraged to throw money.

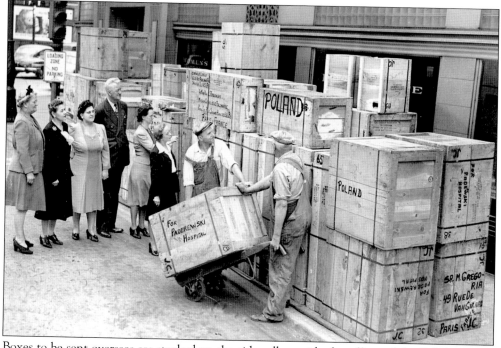

Boxes to be sent overseas are stacked on the sidewalk outside the offices of the Polish Roman Catholic Union (PRCUA) on Milwaukee Avenue. These are labeled for the Paderewski Hospital in Paris. Jan J. Olejniczak, PRCUA president from 1928–1934 and 1941–1946, is the man in the dark suit standing amongst the women organizing this effort.

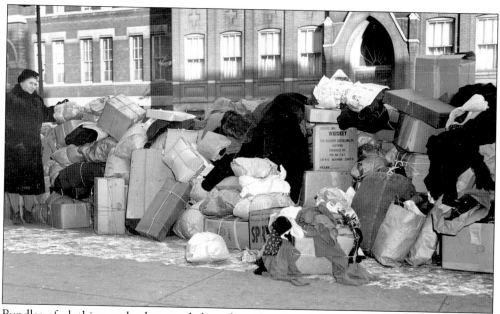

Bundles of clothing and other goods line the sidewalks of Division Street across from Holy Family Academy. Vice president of the Polish Women's Alliance, Franciszka Dymek, is at the left. This photo was published in the *Daily Zwiazkowy* on March 9, 1946, with the caption, "With open hearts we give packages to our brothers."

Ten

ON FOOT IN
OLD POLONIA

The heart of American Polonia was once contained within the one square mile of Chicago's Polish Downtown. The churches, houses, stores, and institutions were filled with Poles and the spirit of Polonia. Some of that can still be found there today. The two Catholic parishes of St. Stanislaus and Holy Trinity continue to minister to older Polish Americans, along with younger Hispanic families, and to new immigrants from Poland. The headquarters of the Polish Roman Catholic Union and the Polish Museum of America defend their historic corner location on Milwaukee Avenue at the Augusta exit ramp of the Kennedy Expressway. The Chopin Theater on Division Street has reopened for live theatrical performances, some of them Polish. Holy Trinity High School is still open but serves students from different backgrounds. And St. Mary of Nazareth Hospital has held firm to its roots on Division Street, in a new building complex serving new populations. Many of the other structures featured in this book still stand but shelter businesses and institutions that are no longer Polish. You can use the map here to find them, walk the same streets, and imagine the life of Polonia that once filled their spaces.

If the heart of Polonia is still here, its reach is much greater. The spirit and energy of Chicago's Polish Downtown has spread from this small neighborhood to practically every corner of the Chicago area. From the first Polish Catholic parish in 1867, today there are 55 Catholic churches in the Archdiocese of Chicago that offer Sunday mass in the Polish language. The largest of these is St. Hyacinth Basilica, not far from the old center of Polish Downtown in Avondale, with six Polish-language masses every Sunday and holiday services so packed that worshippers stand outside and listen to loudspeakers.

The fraternals are still in Chicago, just scattered a bit around the northwest city and suburbs. The Polish National Alliance is at 6100 North Cicero, and the Polish Women's Association is in Park Ridge. The number of Polish societies of all types is as plentiful as ever, covering religious, professional, political, cultural, and social service activities. Not only are there two dailies, *Dziennik Zwiazkowy* and *Dziennik Chicagowski*, still published in Chicago, so are the house organs of the major fraternals. There are at least three weekly news magazines, four radio stations, and two television stations all originating from the northwest side of Chicago and spreading throughout the city to the nation and the world.

Polish stores and businesses of all types can now be found in neighborhoods all over the city and suburbs, but the largest clusters are a bit farther north on Milwaukee Avenue from Avondale to Jefferson Park, and west in the Belmont Cragin neighborhood. They fill the *Real Polish Yellow Pages* with 1,832 pages. There aren't any more parades up and down the streets of Polish Downtown, but the Polish Constitution Day parade is held without fail each May 3rd or thereabouts in Chicago's Loop. The Copernicus Cultural Center promotes Polish cultural programs and performances, and we have a city holiday in March for all Americans to recognize

and honor Gen. Casimir Pulaski.

Possibly most remarkable is the far-reaching role this neighborhood had in establishing a free Polish nation in 1918. It gave generously for war relief during and between both world wars and their aftermath. Then it provided support for pulling the Polish nation out from the oppressor's yoke once again with the collapse of Soviet communism. Poland, the fatherland, is truly free now, the fervent dream of our immigrant forebears almost 150 years ago. Some of the old buildings of Polonia may only contain the ghosts of our Polish past, but the spirit and energy of old Polonia is more alive than ever, contributing an important piece of the puzzle that is America.

Key to Map:

1. St. Stanislaus Kostka church, rectory, and elementary school
2. Holy Trinity church and rectory
3. Holy Trinity elementary school
4. Holy Trinity High School
5. Holy Family Academy
6. St. Stanislaus Gymnasium
7. Polish Roman Catholic Union of America and Polish Museum of America
8. Polish National Alliance
9. Chopin Theater
10. Polish Welfare Association
11. Polish Women's Alliance
12. Northwestern Trust and Savings Bank
13. Northwestern Trust and Savings Bank and Alliance Printers and Publishers
14. Home Bank/ Manufacturers Bank
15. Polish Veterans Home
16. Falcons Hall on Ashland Avenue
17. Falcons Hall on Thomas Street
18. Pulaski Park Field House

Just off the edges of the map and well worth a visit are the following churches
19. St. John Cantius
20. Holy Innocents
21. St. Mary of the Angels
22. St. Hedwig's

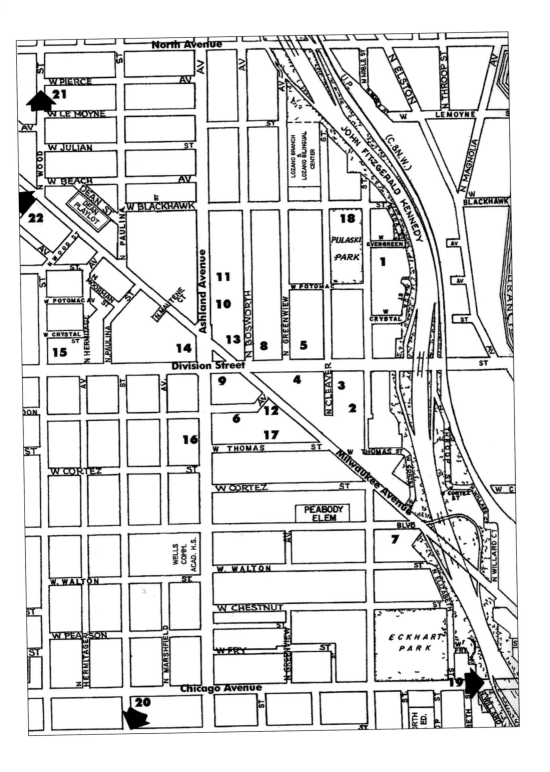

Sunday afternoon in Humboldt Park, 1952.

ACKNOWLEDGMENTS

This project would not have been possible without the full cooperation of The Polish Museum of America (PMA). The bulk of the photographs are from the PMA's extensive historic photographic collection. Thanks to Wallace Ozog, president of the Polish Roman Catholic Union of America and Chairman of The Polish Museum, and Joan Kosinski, president of the Polish Museum, for supporting this project. PMA Executive Director Jan M. Lorys offered facts and suggestions throughout the process and Museum Curator and Director of Exhibits Bohdan Gorczynski provided help along the way. A special thanks goes to Archivist Halina Misterka, whose assistance was critical to the success of this project. She allowed me full access to the fascinating depths of the PMA archives, translating and aiding my search for specific pieces of information. Thanks to Mitch Wiet, president of the Polish American Association, who helped move my dream to reality when I needed it.

Besides the photographs of the PMA, additional photos were provided through the courtesy of the Chicago Historical Society and the Chicago Park District Archives. The Sisters of Holy Family of Nazareth, the Franciscan Sisters of Chicago, and the Resurrection Sisters also searched their archives to help me tell this story with facts and photos. Thank you to Sister M. Gemma, CSFN, and Sister Emilie Marie Lesniak, OSF. All postcards in this book are from my collection, but many of them were originally published by Curt Teich.

I was blessed to receive support and encouragement, a critical eye, and a thoughtful reading from the following people: my faithful associate, Jennifer Kenny, who always pushes me to write better and research more; my good friend, Cheryl Iverson, a "common reader" and unexcelled manuscript editor; and my dear husband, Lee Wesley, who always believes in me and supports my projects. My kids, Matthew and Monica Wesley, didn't see their mother for endless weekends while this book was being written and put together.

I dedicate this book to the memory of my parents, Leon and Myrtle Granacki, who were always proud of me and whom I miss so much; and to the memory of my immigrant grandparents, Joseph and Victoria (Fieczko) Granacki, for having the courage to leave their homeland and come to Chicago. They instilled in me a deep love of my Polish heritage. My brother, Jim Granacki, wanted to see the two of us in this book, so here we are (opposite) with our father in Humboldt Park, in about 1952.

The author may be reached at www.historicpreservationchicago.com.

BIBLIOGRAPHY

Bolek, MA, The Rev. Francis. *Who's Who in Polish America*. New York, New York: Harbinger House, 1943.

Jubilee Books for St. Stanislaus Kostka, Holy Trinity, St. John Cantius, Holy Innocents, St. Mary of the Angels, and St. Hedwig's parishes, Weber High School, various years.

Kantowicz, Edward R. *Ethnic Chicago—Chapter VI, Polish Chicago:Survival Through Solidarity*. Grand Rapids, Michigan: William B. Erdmans Publishing Co., 1977, 1981, 1984.

Kantowicz, Edward R. *Polish American Politics in Chicago*. Chicago, Illinois and London, England: University of Chicago Press, 1975.

Knawa, OSF, Sister Anne Marie. *As God Shall Ordain: A History of the Franciscan Sisters of Chicago 1894–1987*. Lemont, Illinois: Franciscan Sisters of Chicago and Worzalla Publishing Co., 1989.

Koenig, STD, Rev. Msgr. Harry C. *A History of the Offices, Agencies, and Institutions of the Archdiocese of Chicago, Volumes I and II*. Chicago, Illinois: Archdiocese of Chicago, 1981.

Koenig, STD, Rev. Msgr. Harry C. *A History of the Parishes of the Archdiocese of Chicago, Volume II*. Chicago, Illinois: Archdiocese of Chicago, 1980.

Lane, SJ, George A. *Chicago Churches and Synagogues*. Chicago, Illinois: Loyola University Press, 1981.

Marciniak, Ed. *Reviving an Inner-city Community*. Chicago, Illinois: Loyola University Press, 1977.

Parot, Joseph John. *Polish Catholics in Chicago, 1850-1920*. DeKalb, Illinois: Northern Illinois University Press, 1981.

Poles of Chicago 1837–1937. A History of One Century of Polish Contribution to the City of Chicago, Illinois. Chicago, Illinois: Polish Pageant, Inc., 1937.

Polish Falcons of America: Historical Overview. www.polishfalcons.org/history.html. Accessed July 2, 2003.

The Polish National Alliance, A Brief History and *More Detailed Version*. www.pna-znp.org/history%20a.htm. Accessed July 2, 2003.

Polish Women's Alliance of America: About Us. www.pwaa.org/about_us.html. Accessed July 2, 2003.

Prairie in the City: Naturalism in Chicago's Parks, 1870–1940. Chicago, Illinois: Chicago Historical Society in cooperation with the Chicago Park District and the Morton Arboretum, 1991.

Pulaski Park Fieldhouse: Landmark Designation Report. Chicago, Illinois: Department of Planning and Development, 2003.

Radzilowski, John. *The Eagle and the Cross: A History of the Polish Roman Catholic Union of America*. Chicago, Illinois: Polish Roman Catholic Union of America, 2003.

Saint Stanislaus Kostka: History. www.stanislauskostka.org/about.htm. Accessed June 17, 2003.

Sanford, Jr., Charles W. *A History of Healing, a Future of Care: St. Mary of Nazareth Hospital Center Celebrating a Century of Catholic Hospitality*. Flagstaff, Arizona: Heritage Publishers, Inc., 1994.

A Short History of St. John Cantius Parish. www.cantius.org/Parish-Hist.htm. Accessed June 17, 2003.

Thompson, Joseph J. *Diamond Jubilee of the Archdiocese of Chicago*. Des Plaines, Illinois: St. Mary's Training School Press, 1920.

Tomczak, Anthony C., Ed. *Poles in America: Their Contribution to a Century of Progress*. Chicago, Illinois: Polish Day Association, 1933.